Nocturne

Nocturne
CREATURES of the NIGHT

Traer Scott

Princeton Architectural Press
New York

Published by
Princeton Architectural Press
37 East Seventh Street
New York, New York 10003

Visit our website at www.papress.com.

Printed and bound in China by 1010 Printing International
17 16 15 14 4 3 2 1 First edition

Editor: Sara E. Stemen
Designer: Jan Haux

Special thanks to: Meredith Baber, Sara Bader, Nicola Bednarek Brower,
Janet Behning, Megan Carey, Carina Cha, Andrea Chlad, Barbara Darko,
Benjamin English, Russell Fernandez, Will Foster, Jan Cigliano Hartman,
Diane Levinson, Jennifer Lippert, Katharine Myers, Jaime Nelson,
Jay Sacher, Rob Shaeffer, Marielle Suba, Kaymar Thomas, Paul Wagner,
and Joseph Weston of Princeton Architectural Press
—Kevin C. Lippert, publisher

Library of Congress Cataloging-in-Publication Data
Scott, Traer.
 Nocturne : creatures of the night / Traer Scott.
 pages cm
 ISBN 978-1-61689-288-3 (alk. paper)
 1. Nocturnal animals. I. Title. II. Title: Creatures of the night.
 QL755.5.S36 2014
 591.5'18—dc23
 2014006210

To Joan, for seeing light even in the darkest of places

Contents

"Into the darkness they go,
the wise and the lovely."

— Edna St. Vincent Millay

Introduction

My journey into darkness began with visions of brilliantly colored, powdery wings beating softly through the warm night sky. Moths: the mysterious, moonlit cousins of the perky, sunny butterfly—flitting wildly and ever frantically near our porch lights but never coming quite close enough to be truly illuminated. One summer evening it suddenly occurred to me how wonderful it would be to do a photographic series about them. There are more than 160,000 different moth species; I could name maybe two, but there are myriad splendid, exotic, even somewhat frightening varieties. An Internet search revealed moths with bright-green wings, moths with astoundingly intricate geometric patterns, and moths with markings so delicate they could have been painted with a feather. The moths eventually led me to ideas about transformation and nightfall, to predators and prey, and then to the bats who eat moths—and then I had it. The idea for *Nocturne* was hatched, rather appropriately, just after midnight.

In the coming weeks I feverishly researched the roster of nocturnal animals and then began approaching friends and colleagues, who set me up with my first subjects. It is important to note that a great many of the creatures in this book were injured or orphaned wild animals who would never be able to survive in nature. Both of the cougars, for example, were stranded as cubs after their respective mothers were shot by hunters. The great horned owl was hit by a car and has a permanent wing injury. One of the servals has only three legs. By living their lives in semipublic these rescued animals serve as wildlife ambassadors, giving children, in particular,

a chance to connect with an animal that they would probably never otherwise see up close, a chance to be inspired to care about wildlife.

Photographers are observers and documentarians, but we are also interlopers, dabbling in lives and milieus that provoke our curiosity but are not ours. In making this book I worked with wildlife rehabilitation centers, educational facilities, and conservation-oriented zoos. The keepers, nurturers, and educators whom I met were filled with passion and knowledge about their animals and utterly dedicated to their well-being. I got to slip in the back door, meet their fascinating charges, and witness the devotion that drives their lives.

While photographing *Nocturne* I had the opportunity in a few instances to play the role of both observer and nurturer. The beautiful moths that were my very first subjects were obtained as cocoons from scientific supply companies and raised by my family. Studying or photographing large moths is close to impossible unless you hatch them yourself, because their indigenous territories are limited, they are nocturnal, and their lives are extremely brief.

Luna moths, for example, live for only a few days, during which time they don't eat or drink; in fact, they have no mouths. Their sole function during their brief existence is to find a mate and ensure future generations of moths. A romantic friend of mine, touched by their tragically short existence, insists that luna moths live for love, and I suppose, in a way, they do: they live for the love of persistence and evolution.

Luna moths eclose (that is, emerge from their cocoons) in midmorning and immediately scurry up whatever is available; hang upside down; and allow their tiny, crumpled wings to slowly fill with blood. After a few hours the new, bright-green wings will have unfolded, and the moth will begin to dry them by pumping them back and forth a little. Then the moth will rest until nighttime. Luna moths in the wild fly only at night; once the sun sets, the moth will take off in search of a mate. The male

hunts doggedly for his female, following hints and trails of scent until he finds her. Female moths emit pheromones at night, which a male moth's bushy antennae can detect from several miles away. Mating generally occurs just after midnight, and when the act is complete, the female will lay her eggs on a host plant, often on the underside of a black walnut leaf. Both she and her mate will die shortly after.

I felt very beholden to these fragile and beautiful little creatures that we brought into the world and wanted to make their fleeting lives fulfilling in some way. The dilemma of hatching moths is that if you release one alone, it stands very little chance of finding a mate, but if you wait until all of your cocoons have hatched, in the hope of releasing them together, they may not all survive long enough to be released. So I released my moths incrementally, always in the exact same spot: on a nice, leafy hardwood at the edge of a park full of deciduous trees, near the ocean. Each moth would eclose in the morning; I would photograph it during the day and then release it at sundown. I felt that if they weren't going to be able to achieve their mating destiny, the moths should at least be allowed to fly and feel the cool summer night air.

One night, while attempting to guide a sluggish moth to freedom, I spied bats flying overhead and hoped that they would not spot my moth. Little brown bats are quite common in our area. In fact, the previous year, we had one who decided to hang out in our living room after becoming disoriented and flying in through an open window. My husband and I were able to carefully catch him in a towel and send him hurrying off into the night, but many people have no idea what to do when they find a bat in their house. The fear of rabies throws otherwise sane people into an instant panic, even though modern studies prove that a very small percentage of bats actually carry the disease. Still, even when you are armed with that knowledge, seeing a wild bat flying near your sleeping infant, as we did, is a little scary.

In our state it is illegal to kill bats, yet the city does not provide any sort of removal program for them or any other animal deemed "nuisance wildlife." Generally people end up calling private wildlife removal services that charge exorbitant fees. These often promise humane removal, but in many cases if the bat is actually caught rather than convinced to relocate, it is euthanized. If a human or household pet has been bitten, the bat must be killed to test for rabies. The bottom line is that most people don't want bats near their family and will do whatever is necessary to get rid of them, which is unfortunate.

The brown bats that I photographed for *Nocturne* had been removed from people's homes and brought to live at Brown University, where a team studies how they use sonar to navigate flight paths through complicated surroundings. Following our family's domestic close encounter, this was the second time I had seen one of these strange little creatures up close, but it was the first chance I had to truly observe them. Their expansive, veiny wings looked like the skin of a grape stretched over impossibly tiny bones. Their bodies resembled furry, brown balloons that had lost most of their air, leaving saggy skin and what looked like almost no organs. (Of course, they do have organs; they're just very small. An adult brown bat weighs less than half an ounce.) One little brown bat flew at me and landed on my shirt, clinging to the fabric. I was terrified of touching it, lest I crush it, so the handler gently pried it from my shirt and put it in my Little Black Box, where I could photograph it.

One of the ways that I was able to get such intimate photos of the elusive creatures in *Nocturne* was through the magic of this Little Black Box (my affectionate name for the portable studio that my husband built for me, with four walls and a floor all made of black foam core). The Little Black Box was useful to both me and the animals: it provided a black background for the images, and it also gave the animals a safe, dark environment where they tended to feel less threatened while

being photographed. Lens-sized holes in the side allowed my camera to poke through, so the animals did not need to be face-to-face with me, and a diffused flash bounced its bright light down from above rather than directly in the eyes of the subjects. In this way I was able to disarm the critters and get extremely close to them. Obviously, we could put only small, easily handled animals in the LBB. Hedgehogs and frogs and bats and rodents were ideal candidates, but bigger subjects required a different approach. Have you ever tried to corral a porcupine onto a black backdrop? I can truthfully say that I have.

I have always had the handy ability to endure mind-boggling discomfort in order to get the right shot. I have been swarmed by fire ants, trapped in cages, pulled under powerful ocean waves, and bitten more times than I can recall. More often than not, though, I just get covered in something kind of disgusting. Like many photographers who work with animals, I spend a lot of my professional life lying on my stomach, so, naturally, this means I end up coated in whatever is on the ground. That's all well and good if I'm in a grassy yard, but the day I spent in a porcupine habitat was a different story.

When porcupines feel threatened they often emit a very distinctive, extremely unpleasant odor as a warning before launching their infamous signature defense—an army of small, razor-sharp quills. This musk smells exactly like maximum-strength human body odor. At the zoo where I photographed porcupines, no one had warned me about this smell. After I crawled on all fours around the floor of the habitat, the scent on my clothes was so pungent that I could barely stand to breathe. Despite this odoriferous offense, I was rewarded not only with some exciting shots, but with a warm encounter.

The habitat contained an extended family of porcupines, including a one-week-old baby and a blind, wizened patriarch. The old fellow was fascinating: claws long and craggy, eyes cloudy and opaque, his fur a bit patchy and grizzled. While all the other porcupines ignored me, remaining up in their tree,

the elderly creature ambled over and began to climb onto my lap.

Before entering the habitat, I had been instructed not to touch the porcupines; after all, they are wild animals with notorious defense skills. But when the aging porcupine began gently sniffing me, his endearing old face only inches from mine, it was hard to refrain from petting him. It was a thrilling moment of connection with a wild creature.

The baby, though practically a newborn, had the gait and curiosity of a toddler. His walk was wobbly and tentative, and he had a great determination to master the basic skills that are innate to porcupines. I watched as he tried to climb. He made it about six inches off the ground and then fell flat on his back in the dirt. I wanted to scoop him up, but the keeper reminded me not to touch. The little porcupine picked himself up and tried again. He climbed about a foot up the tree, paused, and then slowly descended back to the ground, triumphant.

Unlike the long, bristly coats of adult porcupines, the baby's fur was exceptionally fuzzy, making him look as if he were constantly in soft focus. On the dirt floor of the habitat he looked like a very diminutive, featureless creature, but when he climbed, he appeared more confident, defined, and articulated, so that is when I photographed him.

It was simply impossible to handle many of the animals that I photographed. To remove them from their habitats would have been dangerous for me and the keepers, as well as extremely disruptive and cruel to the animals. In most zoos and sanctuaries, big cats and hyenas, for example, are generally never touched or approached. They are handled only for veterinary purposes, and then they are heavily sedated. With these animals I was usually permitted a closer approach than the general public, but my access was still restricted. However, that did not stop me from having some amazing encounters.

Snow leopards are notoriously elusive, and the female at our local zoo is more like a shadow than a cat. I have overheard

kids and adults alike passing by the habitat, saying things like
"You will never see that cat" or "She's always hiding somewhere."
Indeed, even when she is out of her den during the day, she
usually lounges high up on a rocky ledge, brilliantly camouflaged
among the mottled light and foliage.

The day when I visited to photograph she was nowhere
to be seen, but I waited. Eventually I caught a flash of swishy
leopard tail in one of the rocky dens. She was sleeping. I waited
longer. In about an hour she stretched and arched her back and
then lay back down, her head and drowsy eyes visible at the
opening to the den. I waited. After about forty-five more minutes,
she stretched again, stood up, and walked out into the habitat.
She sniffed some branches, batted at a plant, and then walked
directly over to where I was standing and sat down. For the next
five minutes, this spectacular, enormous cat just sat and stared at
me. As I snapped away, with only a bit of fencing between us,
her intense, penetrating eyes seemed to lock with mine. After a
little while she suddenly appeared to lose interest and casually
strolled off, returning to the high, rocky perch where she so
often keeps watch. She was one of the most profoundly beautiful
creatures I have ever seen, but I can't begin to imagine what she
saw in me.

Every good book sends the reader on a journey. Whether
your means of transport are words or images, by the end you
should feel as if you have climbed a snowy peak, heard a secret
in the softest of whispers, or perhaps flown a little closer to the
sun. For the author, the journey of creation is a life within a life:
conception, birth, a fledgling childhood, maturation, and perhaps
even a death of sorts. A complete life cycle. Every one of my
projects is a little organism that can only thrive through constant
nurturing and dedication. In return, I experience many small
moments of humble awe—and even a brief, privileged glimpse
into the boundless inscrutability of life and existence.

Kangaroo Rat

The charming kangaroo rat is not actually related to a kangaroo but is so named because of its bipedal anatomy and kangaroo-like hopping tendencies. In addition, kangaroo rats also have pouches, but these pouches are on the outside of their cheeks rather than on their bellies and are used for transporting seeds, not offspring. Well adapted to life in the North American desert, the kangaroo rat does not need to consume water but is able to get all of its necessary hydration from the seeds in its diet. The rats' nocturnal lifestyle helps them to stay cool; they sleep in underground burrows during the scorching desert days, only becoming active at night, when the temperatures are lower.

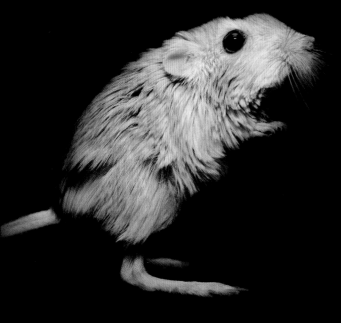

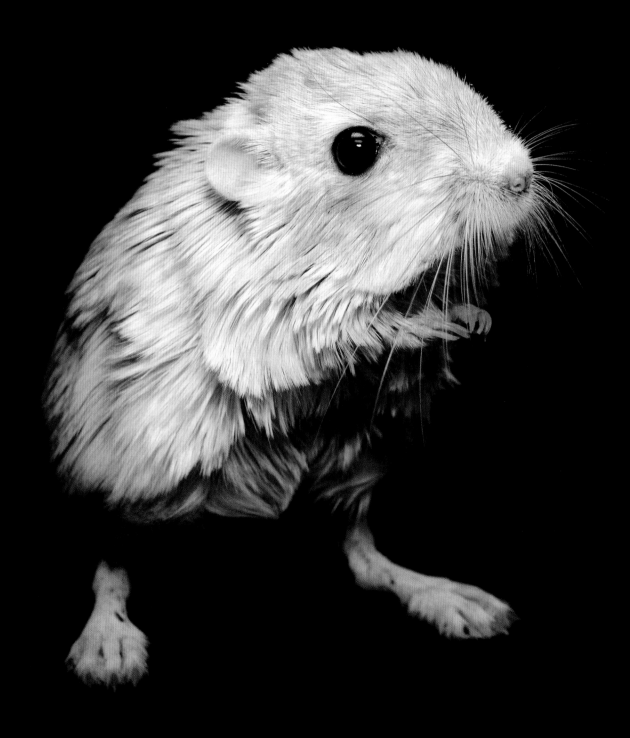

Indian Flying Fox

The Indian flying fox, one of more than 1,100 species of bats, is also known as the giant fruit bat. Found mainly in tropical forests on the Indian subcontinent, this spectacular mammal usually resides in a treetop colony with hundreds or sometimes thousands of other bats. The Indian flying fox can have a wingspan of up to six feet while weighing in at just three pounds or less. These megabats leave the roost about an hour after sunset and will often fly up to forty miles at night to forage for figs, mangoes, bananas, and other ripe fruit.

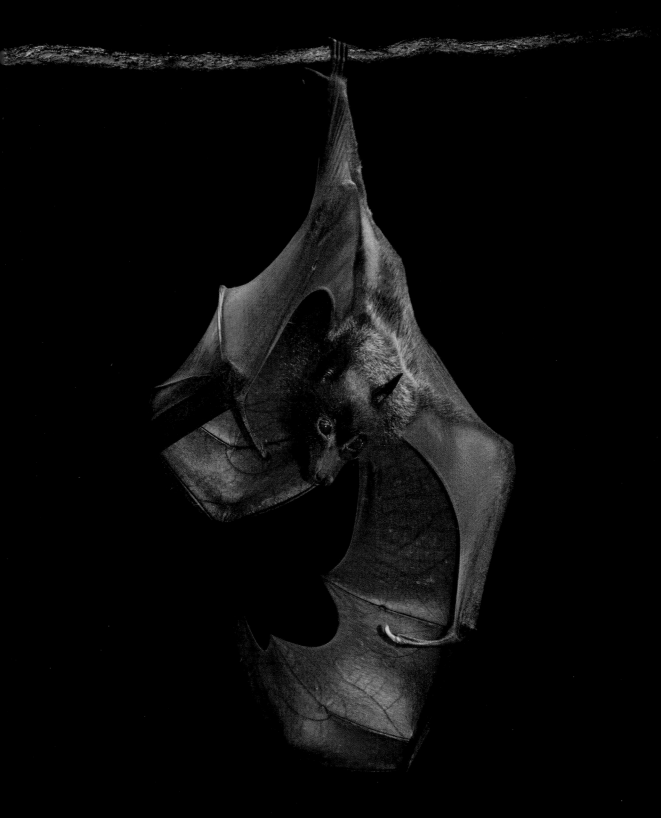

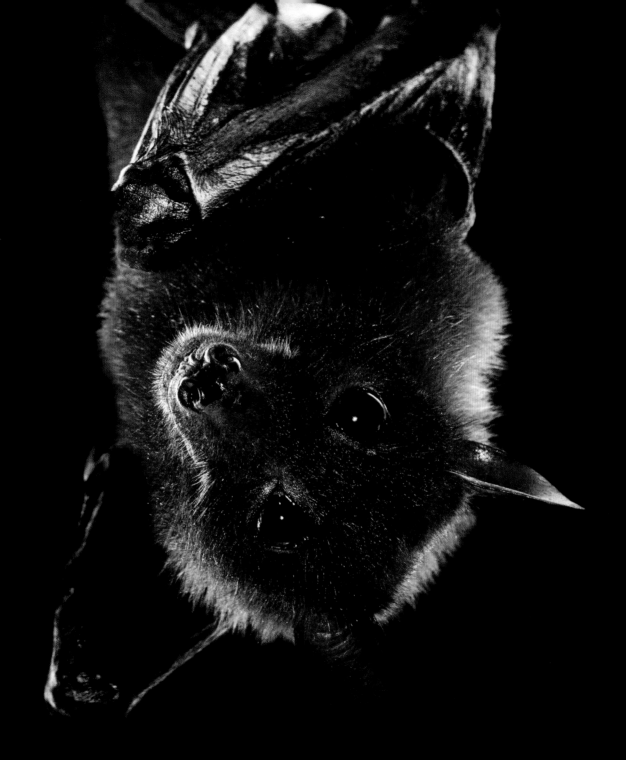

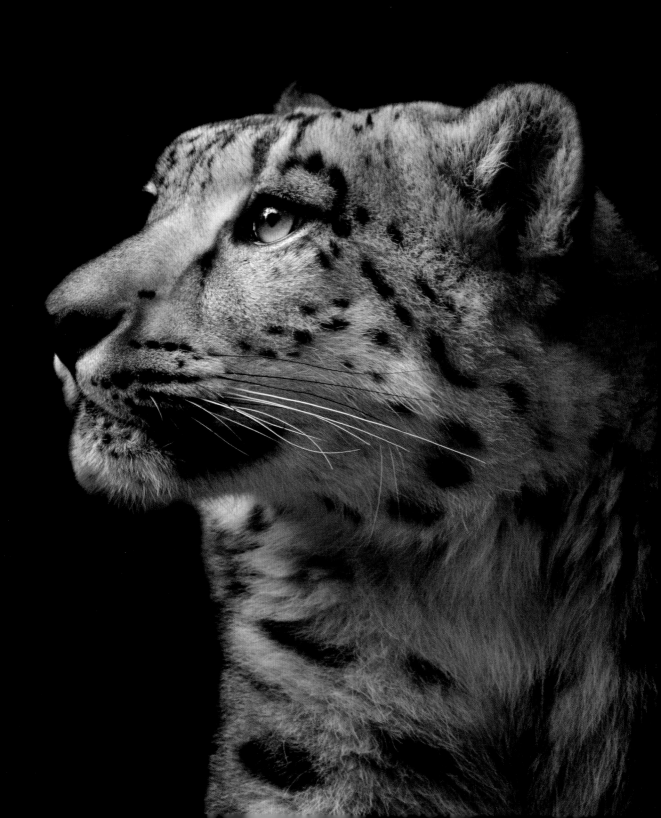

Snow Leopard

Living high in the mountains of central Asia, the reclusive snow leopard is rarely seen in the wild. Snow leopards have highly evolved camouflage and blend in seamlessly with their surroundings, making them almost impossible to spot. The big cat's black and gray markings fade in the winter, helping the leopard to blend in with the changing snowy landscape. Despite this natural disguise and widespread legal protections, snow leopards are highly endangered. The biggest threats to snow leopard populations remain habitat loss through deforestation and poaching for the illegal fur trade. These solitary and silent nocturnal hunters are highly sought for their pelts, which can sell for ten thousand dollars or more on the black market.

African Crested Porcupine

Terrestrial by nature but ungainly on land, the African crested porcupine is actually a very adept swimmer, thanks to hollow quills that make it quite buoyant. Like all rodents, an African crested porcupine is equipped with teeth that are specially designed for gnawing. A porcupine's incisors grow continuously and therefore must be kept trimmed by frequent chewing on hard objects such as rocks or even bones. African crested porcupines are known to collect thousands of bones, which they find during their nocturnal adventures. They bring the bones back to their underground burrows, where they are cached and used as chew toys for the family.

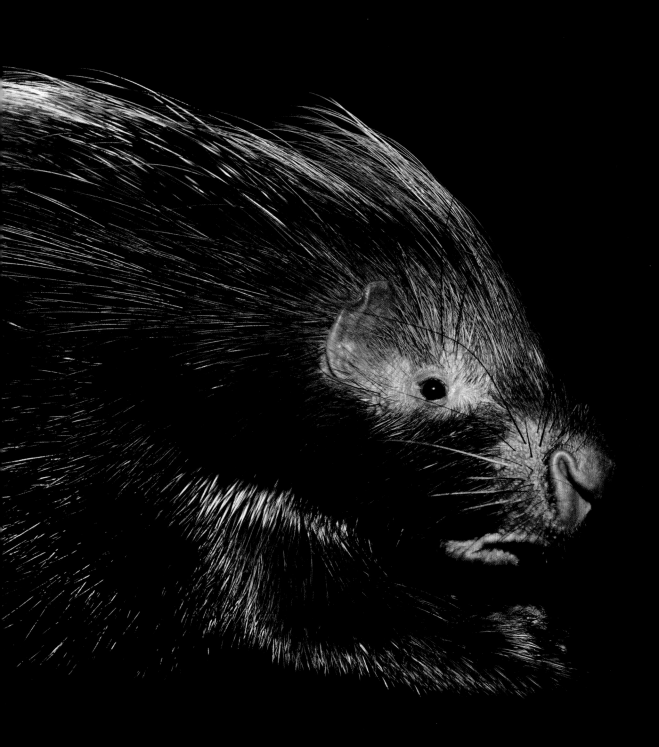

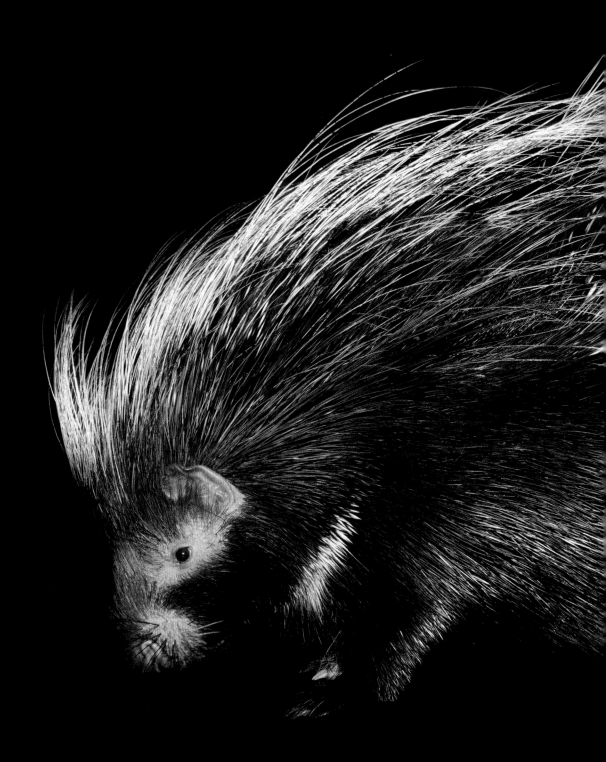

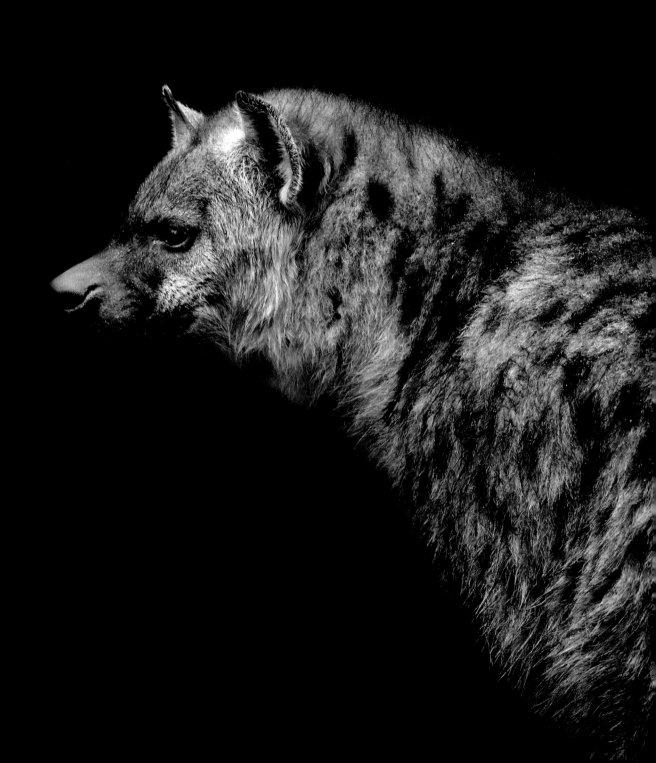

Spotted Hyena

Generally considered a scavenger, the spotted hyena is actually a fast and skilled hunter in its own right. Hyenas live in large matriarchal groups called clans, which have a complex social structure and can consist of up to ninety individuals. Female hyenas are almost always larger than males and also display more aggression, frequently fighting for rank and dominance. Also called laughing hyenas, these intelligent animals are highly communicative within their clans, conveying extensive information to one another through vocalizations that often sound like hysterical human laughter. Proportionally, hyenas have the strongest jaws of any mammal. Because of the hyena's strength, maniacal-sounding laugh, and nocturnal nature, some tribes in Africa have long associated this creature with witches and black magic.

Eastern Screech Owl

The eerie call of these pint-sized owls sounds much more like a high-pitched warble or tremolo than a screech. Because of their small size (generally less than nine inches in height) and adept camouflage, screech owls are much less often seen than heard. The eastern screech owl does not build a nest but instead inhabits hollows or cavities in trees, using the naturally occurring layer of feathers and debris from her previous meals as a lining on which to lay her eggs. Eastern screech owls hunt almost exclusively at night, using a more passive approach than many other owls: they sit in the low branches of a tree waiting for prey to pass below and then pounce!

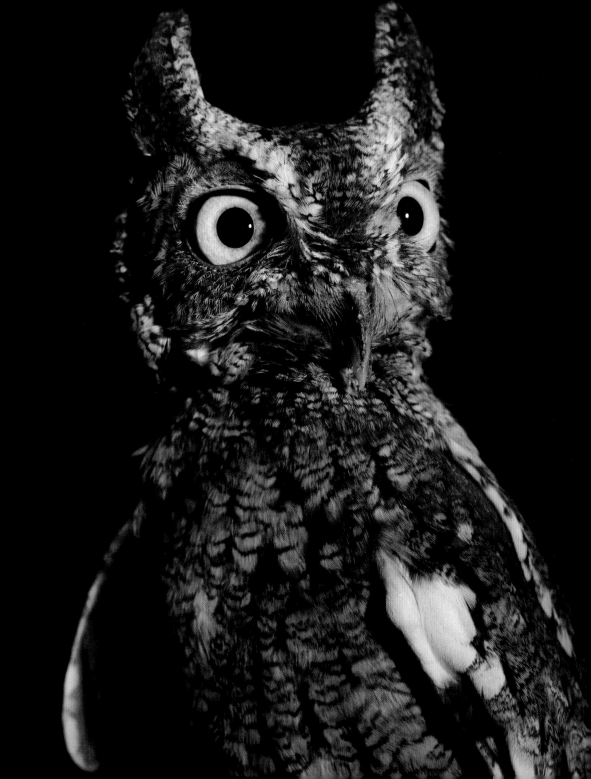

Two-Toed Sloth

Slow-moving sloths spend the majority of their lives hanging upside down; they eat, sleep, and even give birth while hanging from tree limbs. The two-toed sloth is found mainly in the jungles of Central and South America, where, moving only when absolutely necessary, its maximum speed is about six feet per minute. Although the modern two-toed sloth is about the size of a cocker spaniel, many extinct sloth species were ground dwelling and known to grow as large as elephants! The two-toed sloth is exclusively nocturnal and generally moves to a different tree each night.

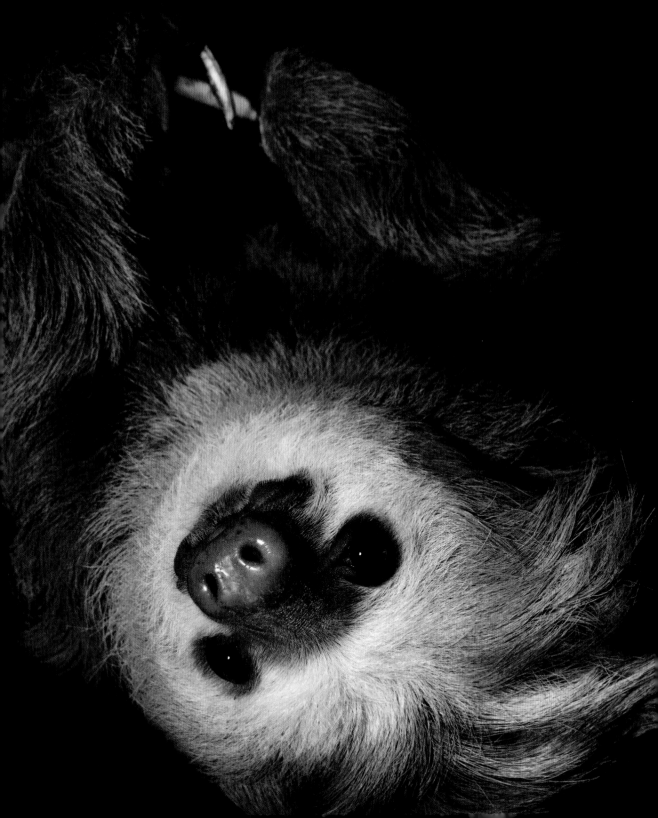

Burmese Python

One of the five largest snakes in the world, the Burmese python often grows to twelve feet in the wild. Excellent swimmers, Burmese pythons can stay submerged for thirty minutes. Although wild pythons are generally very frightened of humans and will not initiate an attack, great care should be taken with both wild and pet pythons. A nine-foot Burmese python can easily kill a human child, while a fully grown adult has the ability to overpower and suffocate a human adult male. A python does not need to eat very frequently and consumes little more than its own body weight in food annually. These powerful nocturnal predators live in the rain forests and wetlands of Southeast Asia, where their diet consists mainly of small mammals that are also active at night.

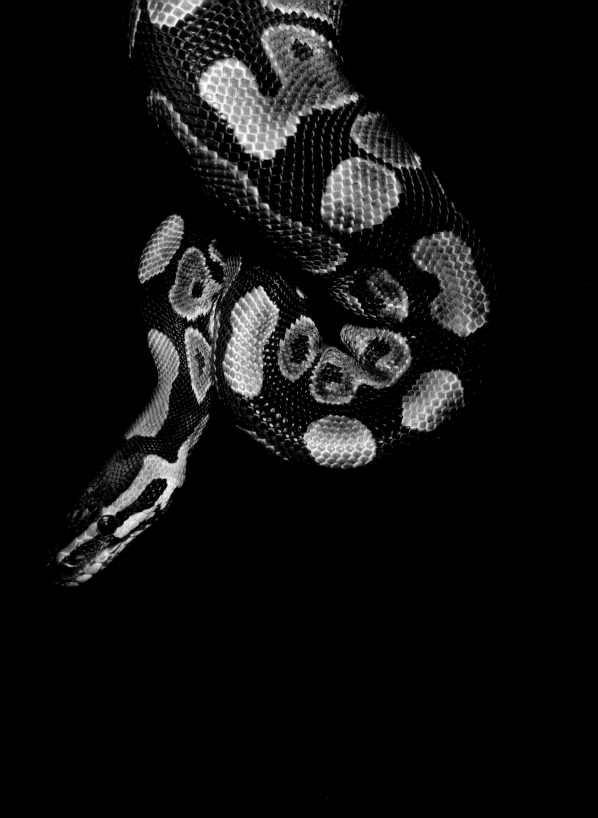

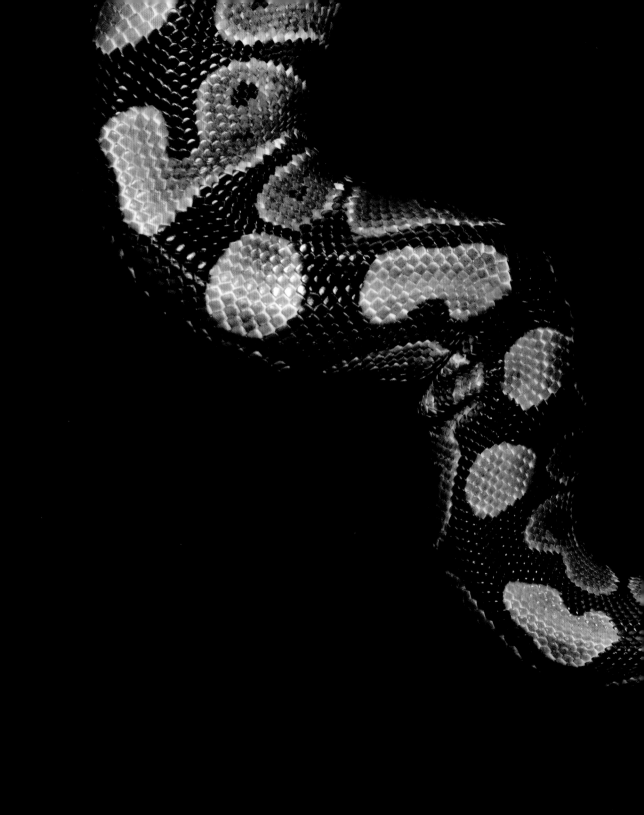

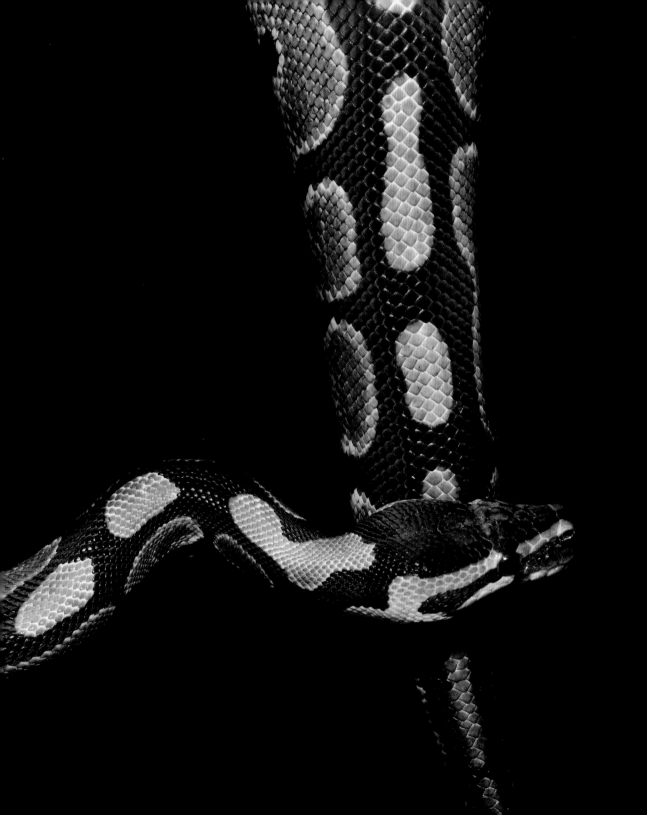

Fennec Fox

Although the fennec fox is the smallest of all fox species, it boasts the largest ears, relatively speaking. Beyond making these tiny, Chihuahua-sized foxes inimitably adorable, their disproportionately huge ears serve to keep the fennec from overheating by dissipating body heat. A fennec's ears also enhance its exceptional hearing; often these four-pound foxes are able to hear prey underground! Fennecs are found primarily in the deserts of North Africa, where their nocturnal habits help them to evade the searing desert heat.

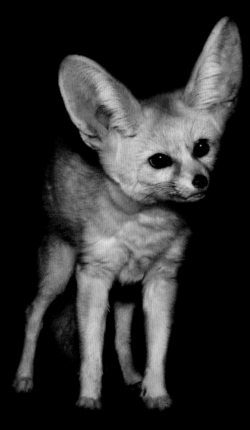

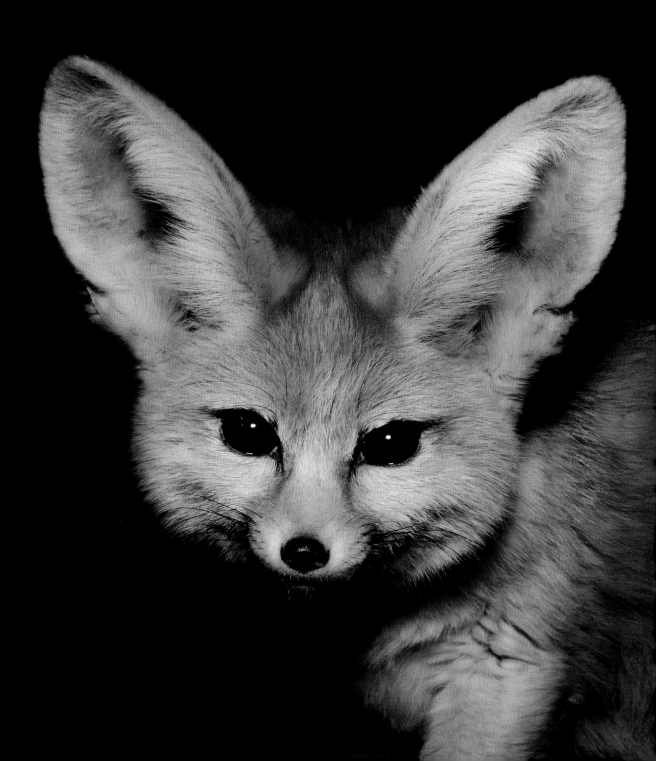

Luna Moth

The luna moth is one of the largest moths in North America, with wingspans often reaching almost five inches. The lime-green luna moth has prominent markings on its wings that greatly resemble eyes. These "eyes" are meant to distract predators from the moth's small, fragile body. The life of a luna moth is brief; most live less than one week, just long enough to find a mate and reproduce. They have no mouths or digestive systems and do not eat or drink after leaving the cocoon. Luna moths will only fly at night.

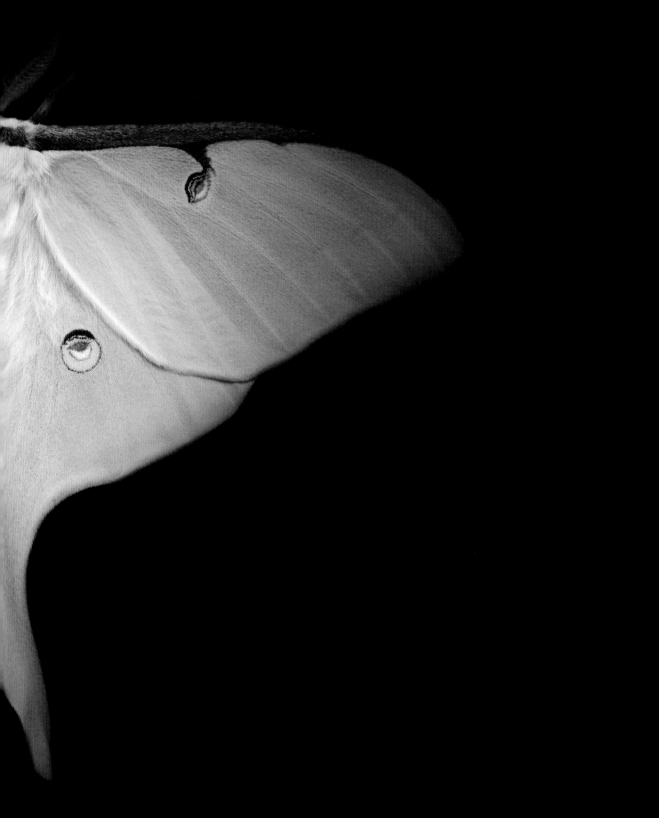

Serval

These elegant cats were once worshipped by the Egyptians for their grace and strength. Despite being barely twice the size of an average house cat, the serval is the most effective hunter of all wildcats, with successful kills approximately half of the time. (In contrast, lions have a hunting success rate of less than 20 percent.) With the longest legs relative to body size of any wild cat, the serval is also one of the fastest, able to run at speeds up to fifty miles per hour. Servals are solitary nocturnal hunters; they primarily prey on rodents but are also known to eat birds, reptiles, fish, and frogs.

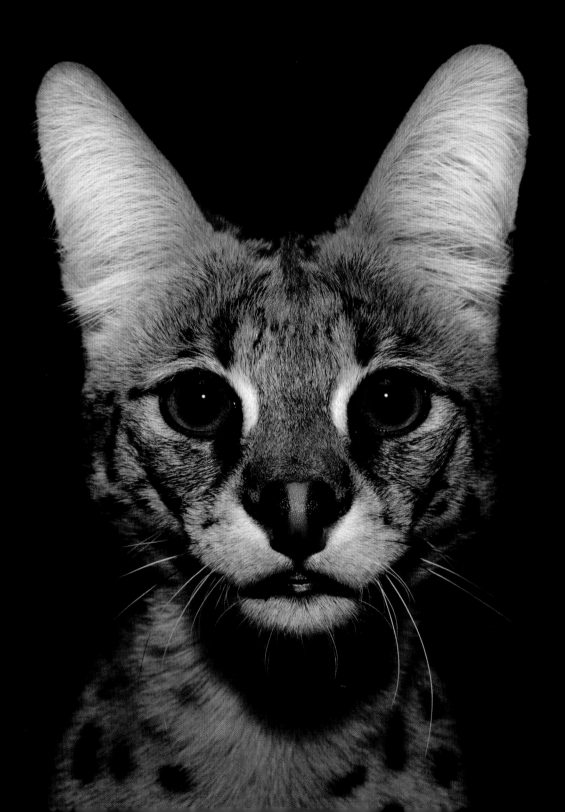

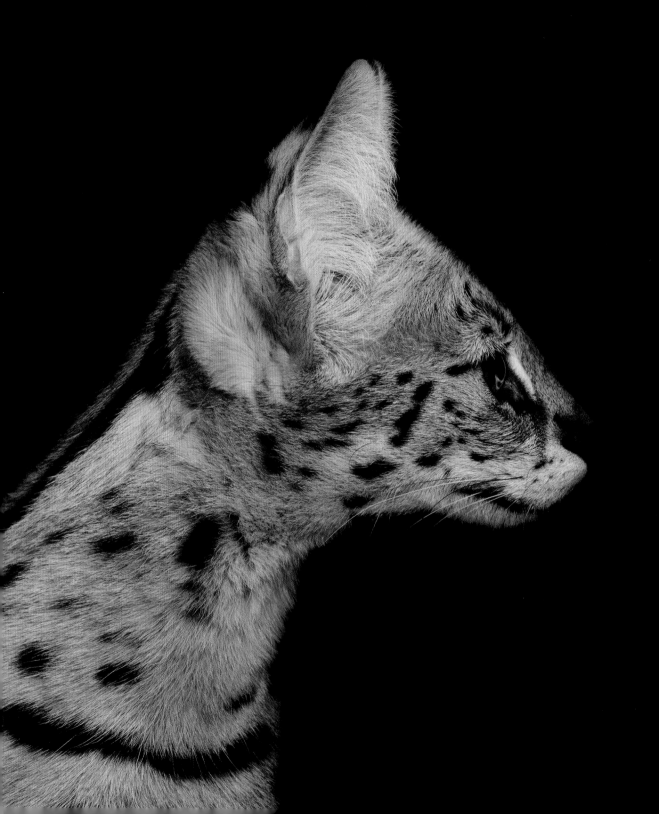

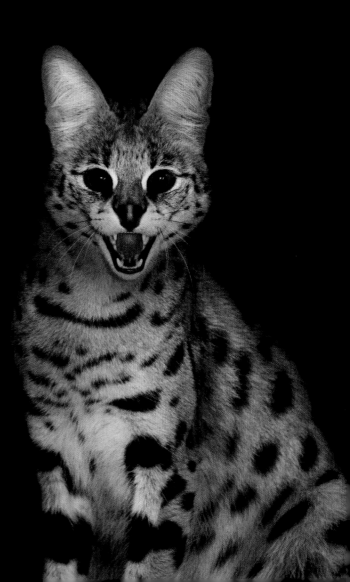

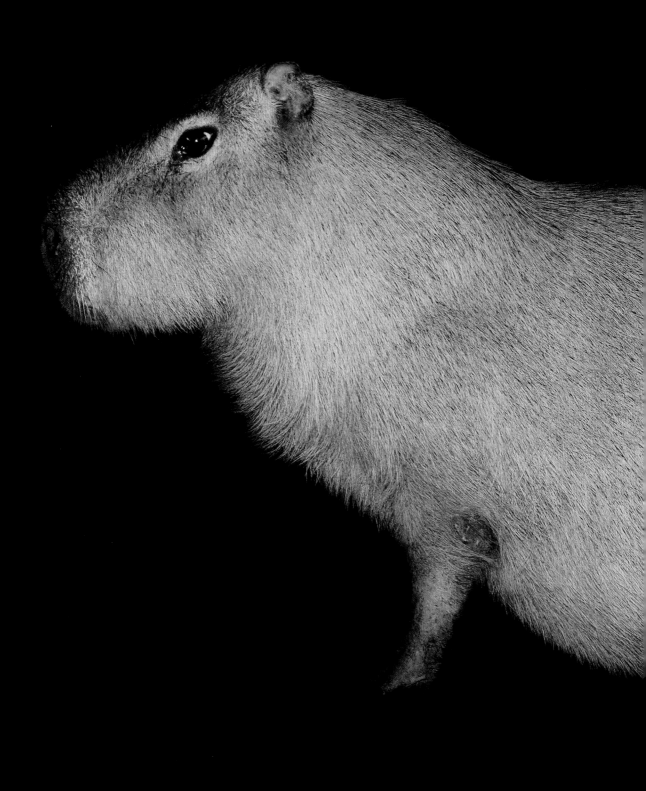

Capybara

A giant cousin of the guinea pig, the capybara is the largest rodent in the world, with adults generally weighing between 80 and 140 pounds. Known to be excellent swimmers, the semiaquatic capybara has webbed feet and can remain underwater for up to five minutes in order to evade predators. They are equally well adapted to land, capable of sprinting twenty-two miles per hour. Capybaras are highly social and live among large groups in the savannas and dense forests of Central and South America. Capybaras are traditionally crepuscular, meaning that they are most active at dawn and dusk; however, in areas where humans have begun to encroach on their territories, the animals have adopted a nocturnal lifestyle to avoid the threat of people.

Barn Owl

During the day, the aptly named barn owl tends to roost in dark, quiet places, such as abandoned barns and thick trees, emerging only at dusk to hunt small mammals by flying over open fields, marshlands, and meadows. A strictly nocturnal hunter, the barn owl does not rely on sight to find prey but instead hunts by sound. Barn owls have acute hearing, and they can even detect movements of small prey under ground cover such as leaves or even snow. Several unique biological adaptations contribute to the barn owl's sensitive hearing, including a very pronounced facial disk, which collects sounds and guides them into the ears. In addition, barn owls' ears are set asymmetrically, with one higher than the other, which helps them to judge the distance and direction of sound in the darkness.

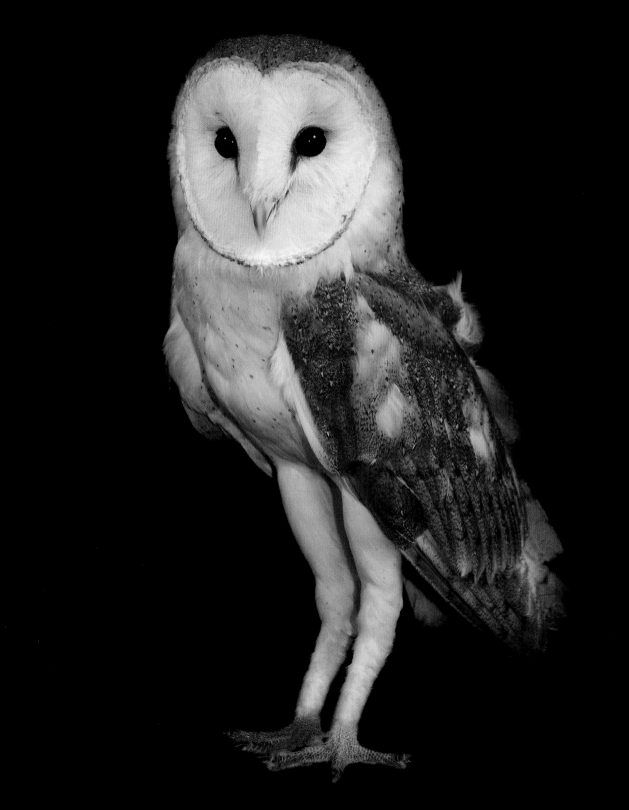

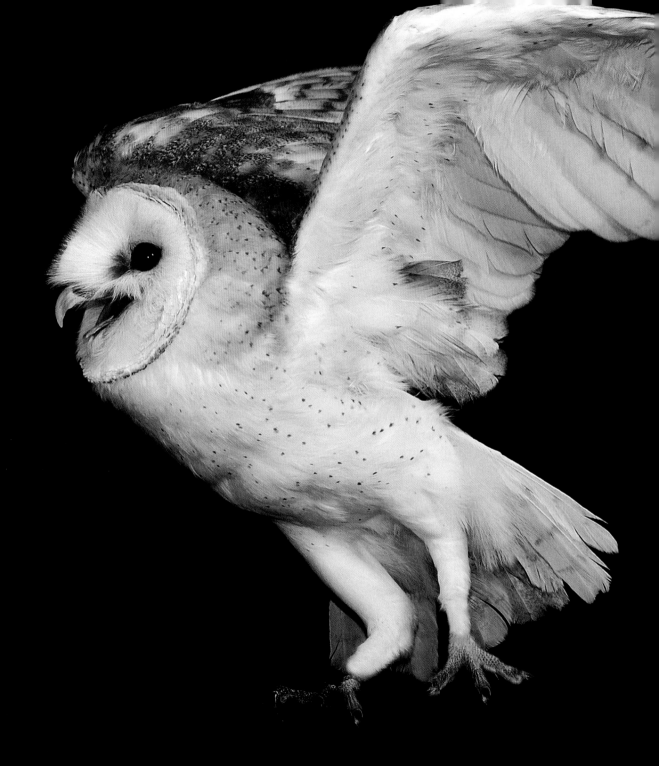

Giant Anteater

The bizarre-looking giant anteater, also sometimes known as the ant bear, is generally five to seven feet long and can weigh up to one hundred pounds. The giant anteater has an elongated snout and a two-foot-long tongue, but no teeth. The anteater uses its sharp claws to rip open termite or ant mounds and then inserts its long snout into the cavity. Huge salivary glands in the mouth produce very sticky saliva that coats the tongue. As the tongue flicks in and out, insects stick to it and are carried into the anteater's mouth. One giant anteater may eat as many as thirty thousand ants in one night! The giant anteater is known to be either nocturnal or diurnal, depending on climate and the proximity of humans, but most sleep during the day and feed after sunset.

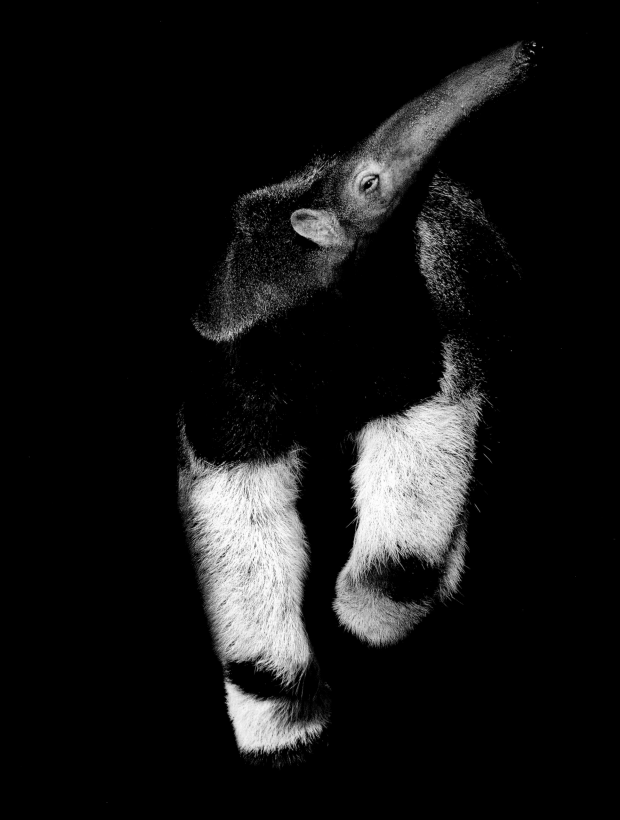

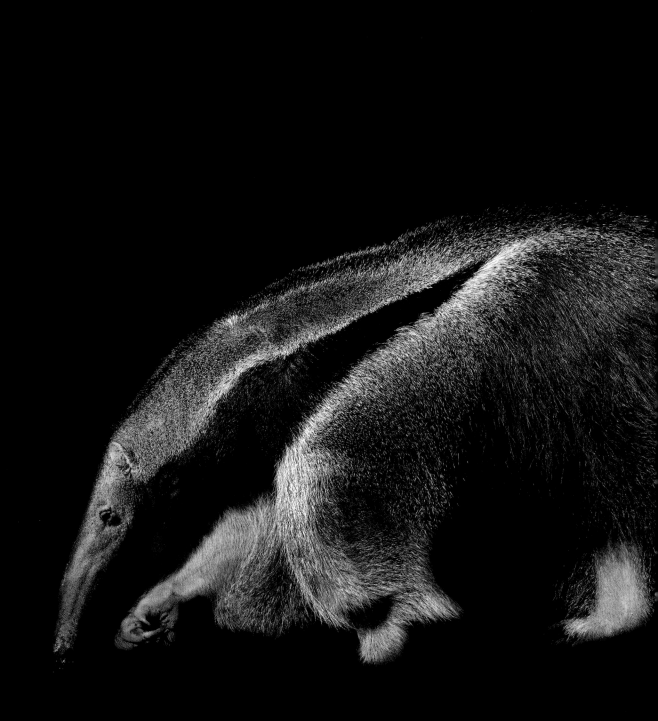

Spotted Salamander

Triggered by the annual spring rainy season, an adult spotted salamander returns to the same pool for breeding every year of its life. A spotted salamander lays eggs in clutches of up to two hundred, which are attached to aquatic vegetation by a jellylike coating. After the eggs hatch, the larvae must stay in the water for up to three months before maturing enough to venture onto nearby land. An adult salamander may look defenseless, with its supple, delicate skin, but the glands on its back and tail actually produce a foul-tasting toxin that quickly deters predators. These nocturnal amphibians also stay out of sight during the day, often hiding under rocks or leaves or even squatting in other animals' burrows until nighttime, when fewer predators are awake.

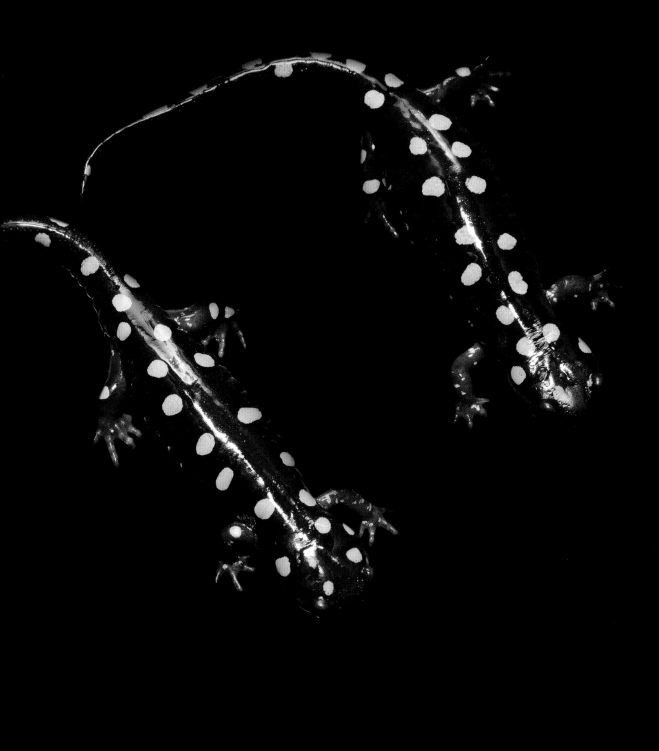

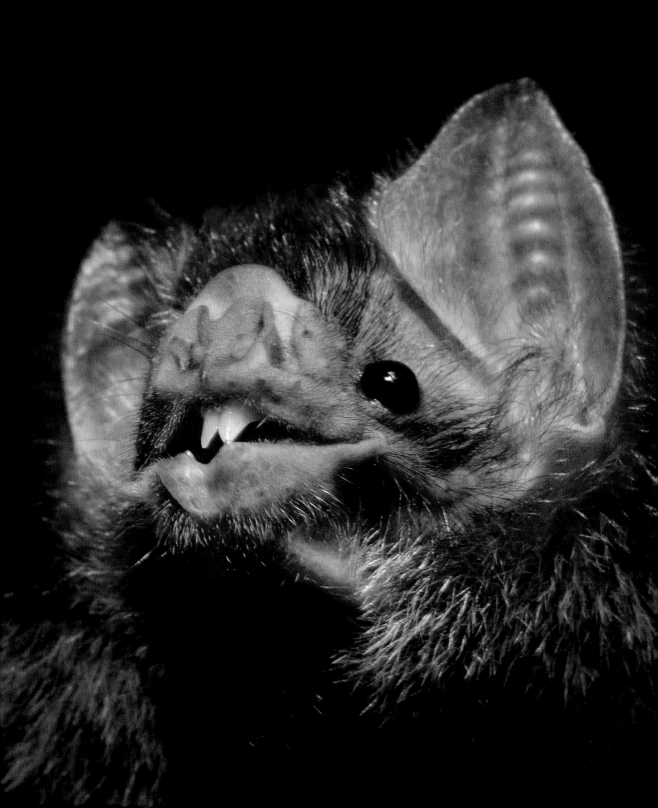

Common Vampire Bat

The vampire bat survives solely on animal blood, but, contrary to popular belief, it does not suck the blood from its victims. Instead, the tiny bat uses its razor-sharp, fang-like teeth to make a small incision in the skin and then licks up the animal's blood as it trickles out. The vampire bat's saliva contains an anticoagulant to keep the blood flowing! These flying mammals feed primarily on cows and other large livestock, which generally are not harmed by the relatively small loss of blood. However, because bats can be carriers of rabies, the vampire bat is considered a pest. Like other bat species, vampire bats are strictly nocturnal and are only active at night.

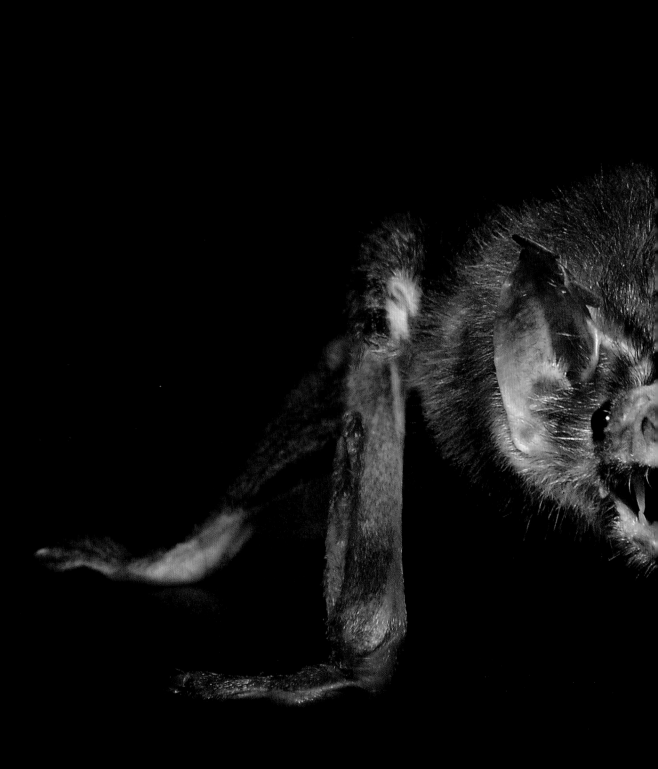

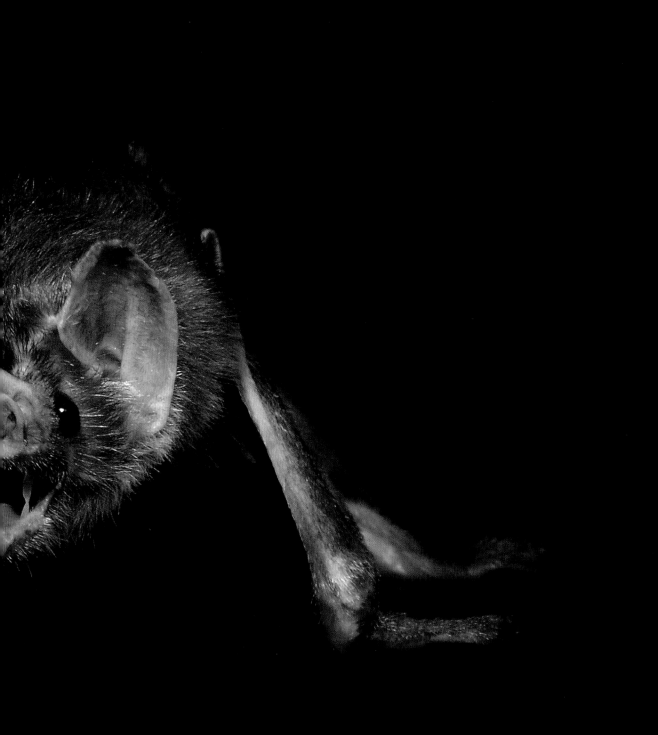

Raccoon

The raccoon is known for its intelligence, adaptability, and perceived capacity for mischief. A raccoon's hands are very dexterous, much like the hands of humans and primates. These nimble forepaws make it easy for them to pick up and eat everything from nuts and berries to human garbage. Centuries ago, Spanish colonists adopted the word *mapache* for these notorious bandits, which translates literally as "one who takes everything in its hands." A common misconception about raccoons is that they only appear in the daytime if they are rabid or ill. Although much more active at night, raccoons are not strictly nocturnal; often females or juveniles will come out during the daylight hours to forage for food.

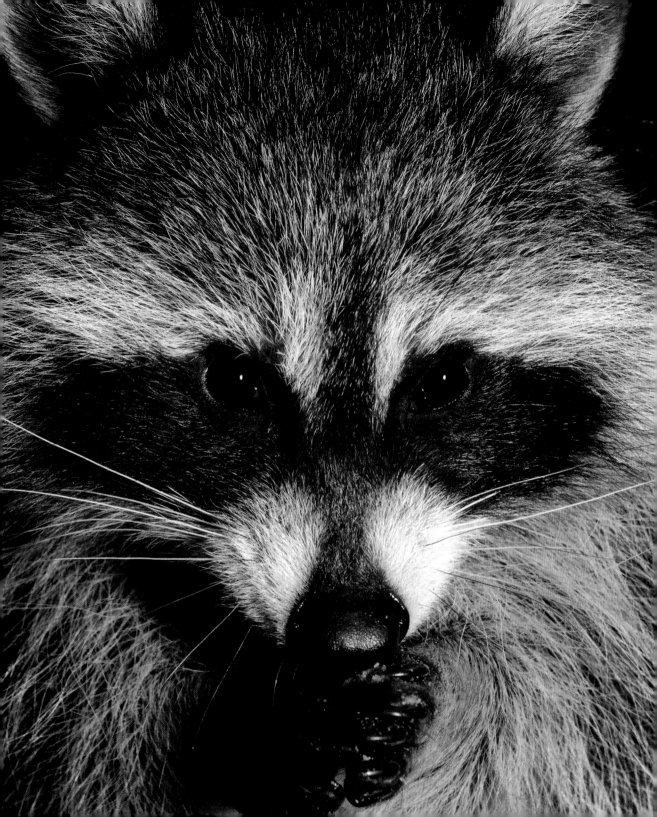

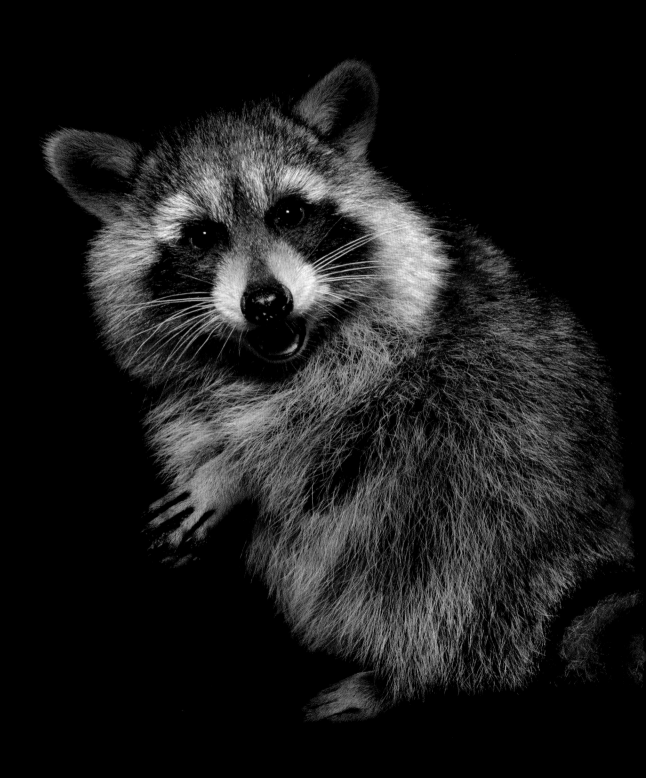

Rococo
Toad

These enormous toads can reach one foot in length, making them the largest species of wild toad in the world. Native to South America, the rococo toad can live for up to thirty-five years, eating insects, mice, fish, or even small birds. When threatened, the rococo toad inflates its body to become even bigger and makes huffing noises. The rococo toad is frequently mistaken for the highly toxic cane toad, which is also nocturnal.

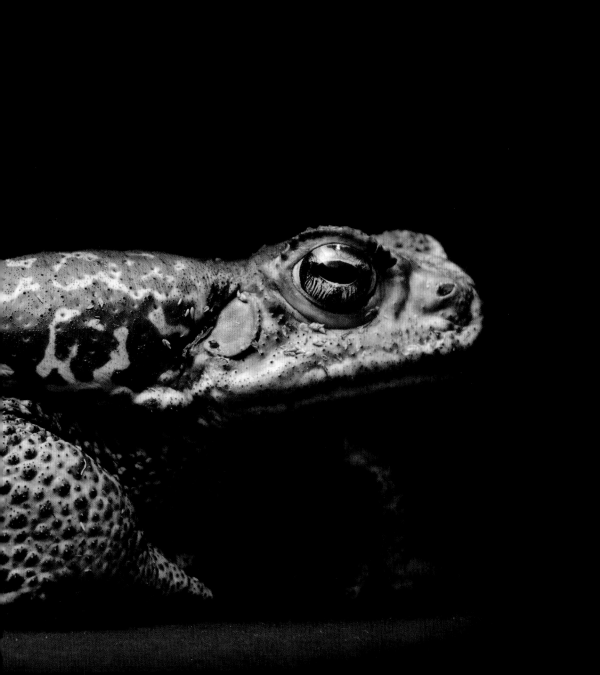

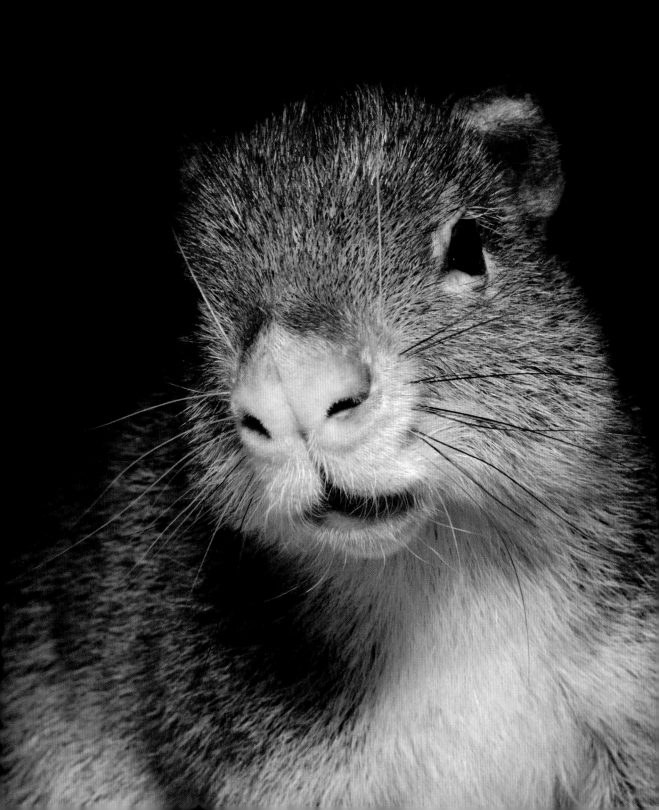

Common Agouti

Common agoutis are related to guinea pigs and share
a similar appearance, but they walk on their toes rather
than on flat feet. They are very fast and nimble runners;
in fact, a newborn agouti can run as soon as an hour
after birth. An agouti mates for life and can live for up to
twenty years, a remarkably long life for a rodent. Agoutis
are found in Central and South America and feed
primarily on fallen ripe fruit, which they are able to hear
drop from faraway trees. There is debate over whether
these animals are instinctually nocturnal or diurnal, but
in areas where they are hunted or threatened by the
presence of humans, agoutis live a strictly nocturnal
lifestyle to avoid encountering people.

Hedgehog

Hedgehogs are extremely vocal. They communicate their preferences and moods using a repertoire of grunts, chirps, hisses, and squeals. When truly threatened, a hedgehog's primary defense is to roll up into a tight ball with all of its spines facing outward. The quills—more than seven thousand of them—on a hedgehog's little body not only protect against predators but also help act, paradoxically, as a soft cushion. Though very good at climbing, hedgehogs often have trouble getting back down again. When faced with a tough descent, they may opt to just curl into a ball and drop, allowing the spines to soften their fall. Hedgehogs are nocturnal because most of the tiny animals that they feed on are nocturnal, too. Common night dwellers such as insects, snails, toads, and earthworms make up the bulk of the hedgehog's diet.

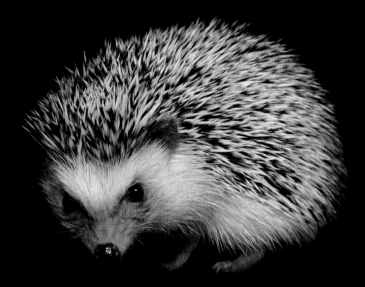

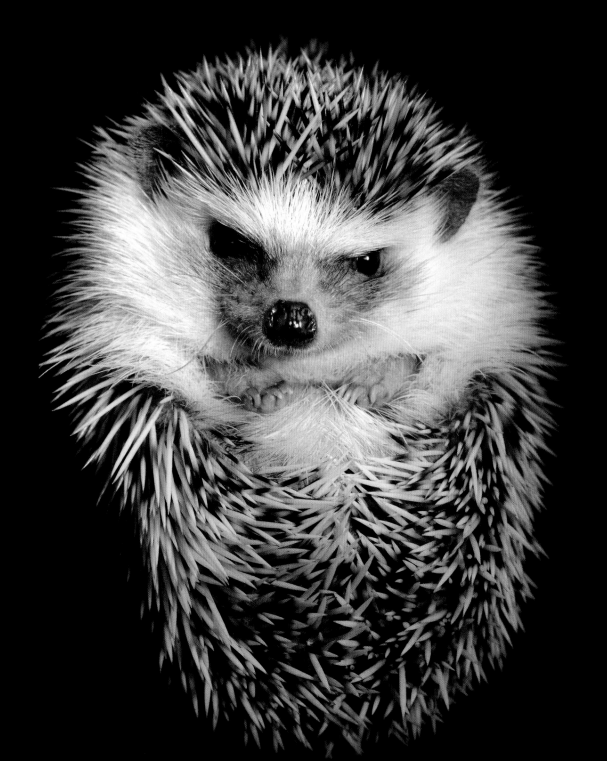

Cougar

Since humans are the sole predatory threat to mature wild cougars, cougar kittens are orphaned most frequently as a result of sport hunting, poaching, or illegal culling. Only female cougars are involved in raising young, and a mother spends an average of eighteen to twenty-four months with her brood, teaching them how to hunt myriad prey, from mice to deer. Cougars, like all cats, are considered obligate carnivores, which means that a diet consisting exclusively of meat is biologically essential for their survival. Cougars can be either nocturnal or crepuscular, often doing much of their hunting in the twilight and early-morning hours.

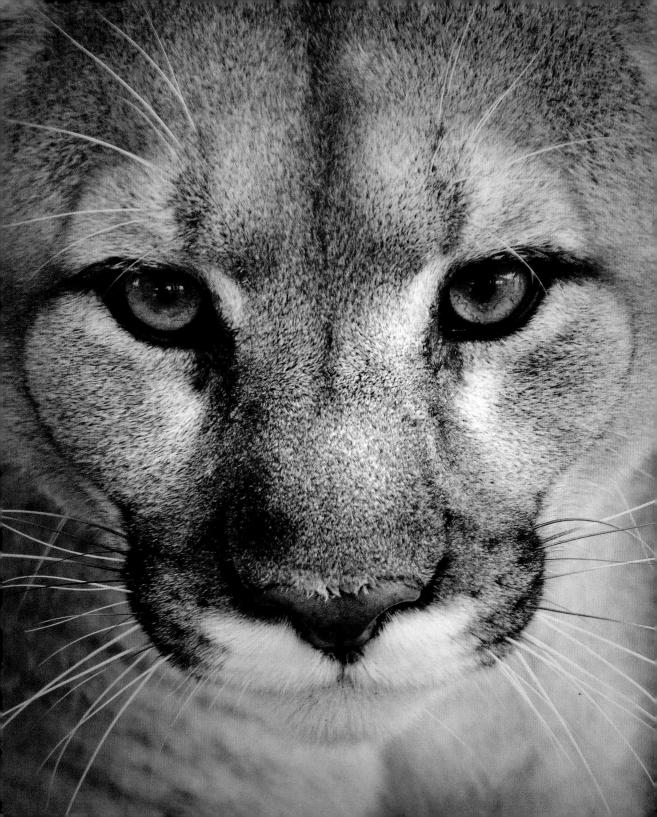

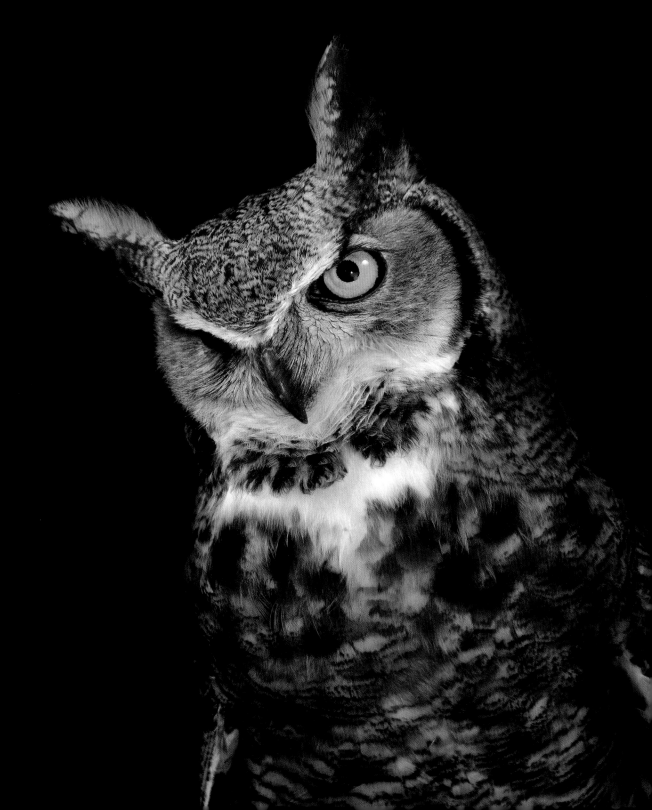

Great Horned Owl

The great horned owl is one of the heaviest owls in North America, weighing from three to five pounds and boasting up to a fifty-inch wingspan. The "horns" on either side of a great horned owl's head are actually tufts of feathers, which are believed to assist in camouflage. Great horned owls are nocturnal avian hunters who strike from above, using their razor-sharp talons to capture and kill prey. Like many other owls, the great horned owl swallows its prey whole and then later regurgitates pellets consisting of undigestible material such as bone and fur.

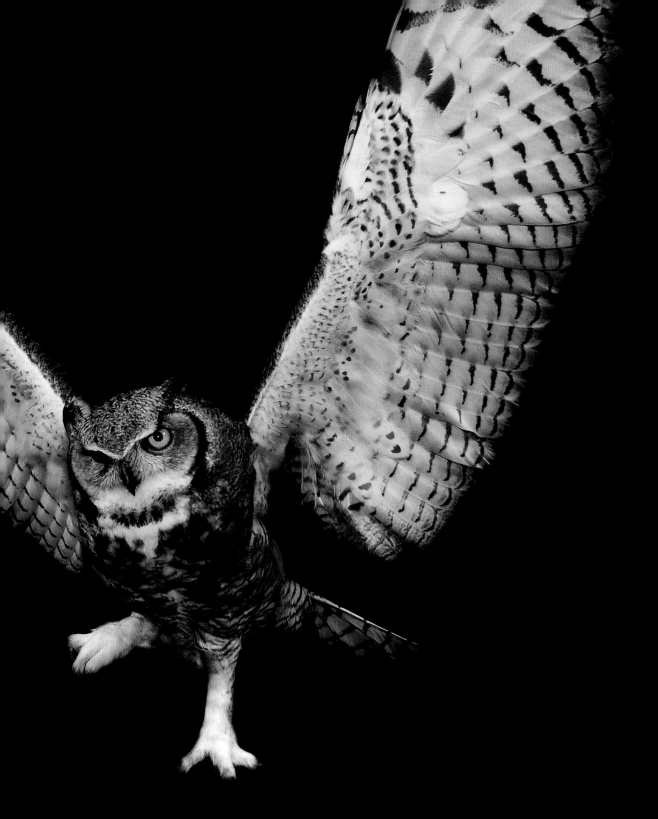

Gray Tree Frog

The gray tree frog rarely leaves the safety of tree branches except during breeding season and in winter, when it hibernates, hidden on the forest floor under leaves or debris. This amazing frog can withstand up to 80 percent of its body being frozen. During hibernation the frog's heart, lungs, and other organs do not function. In the spring the gray tree frog simply thaws out and hops away. Large choruses of these strictly nocturnal chirping frogs can often be heard at night in April and May.

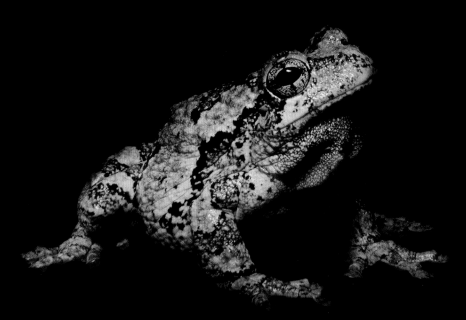

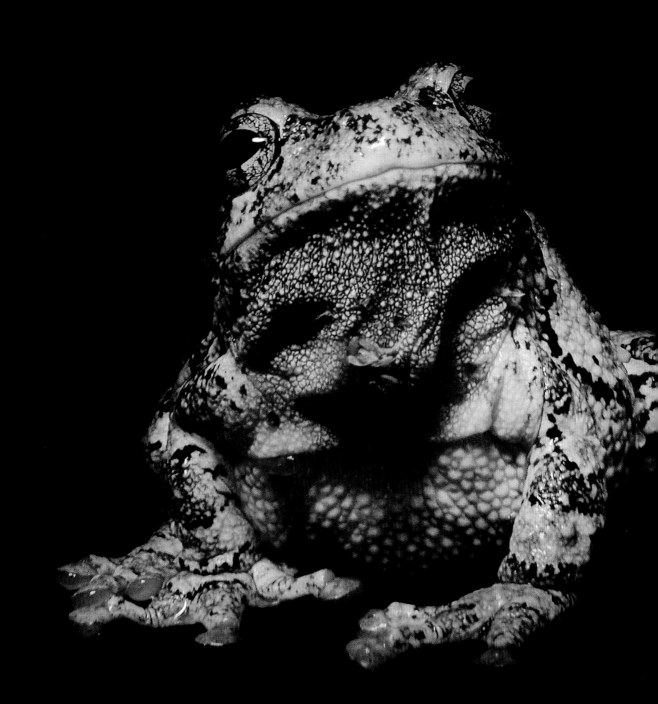

Domestic Cat

Arguably the most popular pet around the world, the
house cat can be found in almost half of all American
households, with approximately 220 million of these
animals in existence worldwide. Beloved for their unique
brand of companionship and superior vermin-hunting
skills, cats have been domesticated for more than five
thousand years but can trace their lineage to African
wildcats. It is easy for modern cat owners to forget that
their pets are, in fact, fierce nocturnal hunters who tend
to be much more active (and noisy) at night.

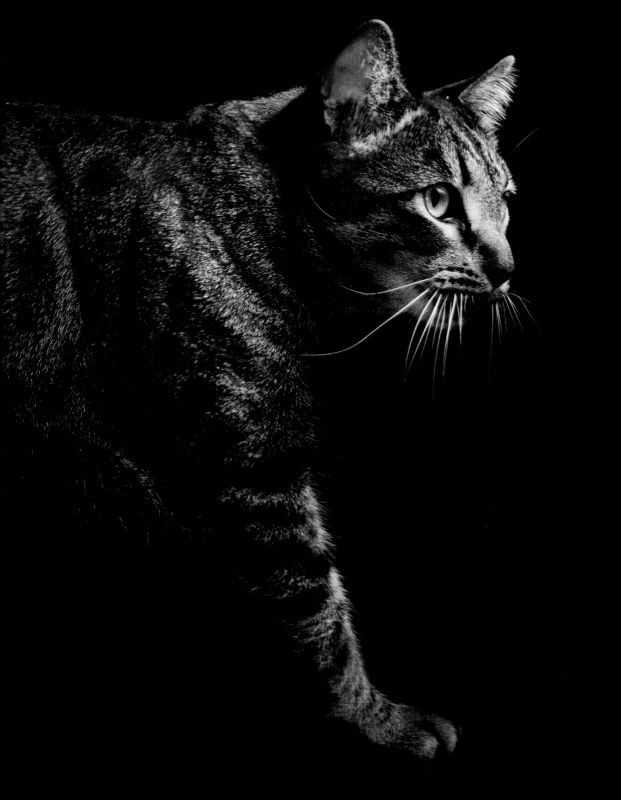

Opossum

These marsupials have adapted a notorious, theatrical defense mechanism that is exhibited when they are threatened or injured: playing dead. *Apparent death*, as it is scientifically called, is an involuntary physiological response similar to fainting that causes the opossum to appear and smell like a dead or dying animal, thereby deterring predators who generally prefer live prey. An opossum will remain unconscious anywhere from thirty minutes to four hours. These nocturnal foragers have a very flexible diet and are able to eat rodents, vegetables, fruit, insects, slugs, human scraps, cat and dog food, and even the bones of the roadkill they consume.

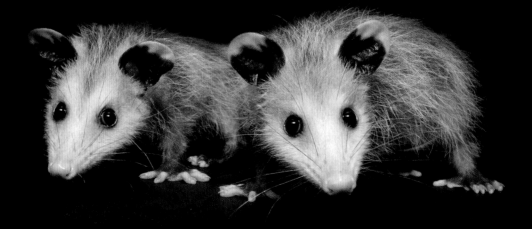

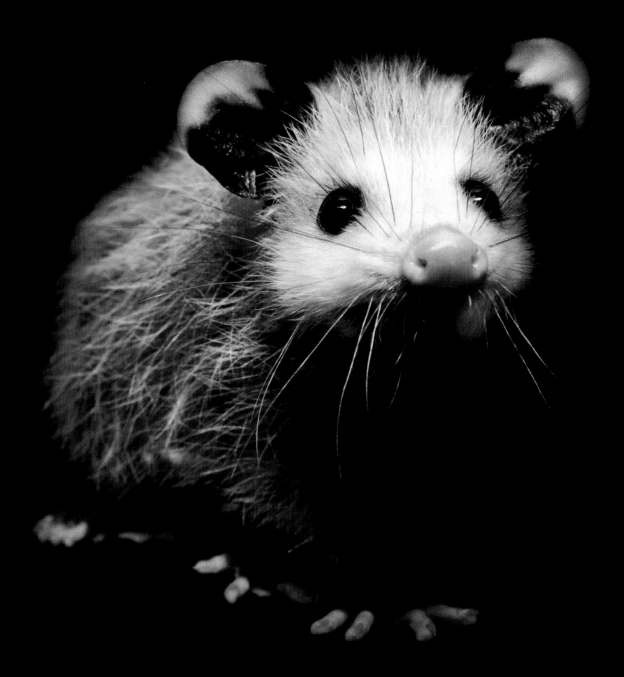

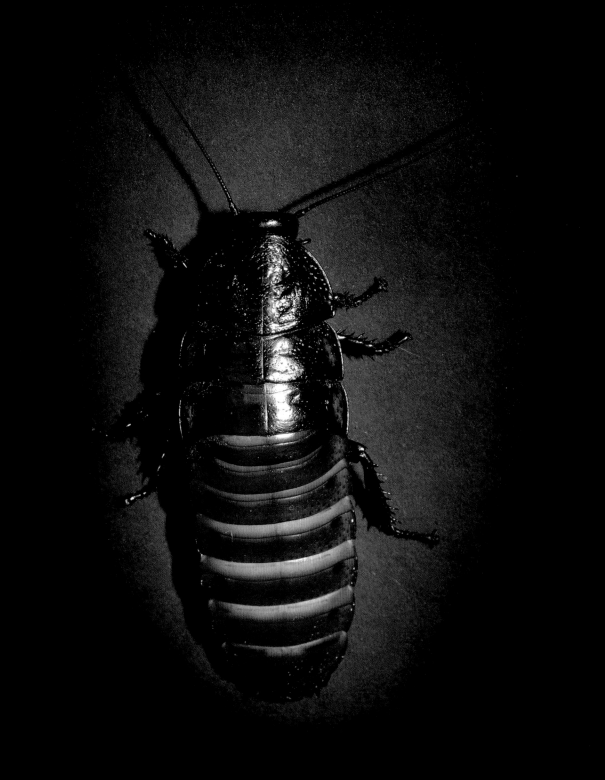

Madagascar Hissing Cockroach

Found only on the island of Madagascar, these giant, wingless cockroaches can reach three inches in length. Their characteristic snakelike hissing sound is used to ward off predators and is produced by forcing air through abdominal respiratory openings. Madagascar hissing cockroaches live in colonies and will often hiss in unison, producing a loud, intimidating noise. Males are quite aggressive and have horns, which they frequently use in battles for dominance with other males. Like all cockroaches, the Madagascar hissing cockroach is nocturnal, but males can sometimes be seen fighting during the day.

Corn Snake

One of the origins of the corn snake's name is said to be the pattern of scales on its belly, which resembles Indian corn. These harmless snakes, indigenous to the eastern United States, are often mistaken for the lethal copperhead but are, in fact, not venomous and pose no threat to humans. The docile corn snake is actually quite beneficial to people, as it helps to control the wild rodent populations that often destroy crops. Corn snakes are constrictors and kill their small prey by literally squeezing the life out of them. Fortunately for nearby rodents, most snakes do not eat every day, and the corn snake is no different. This slender snake generally engages in nocturnal hunts every two to three days.

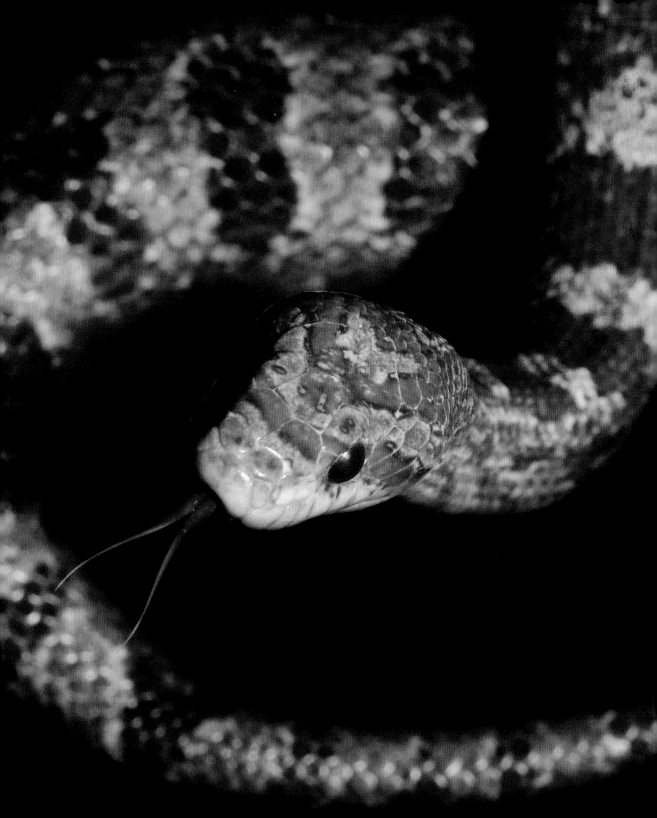

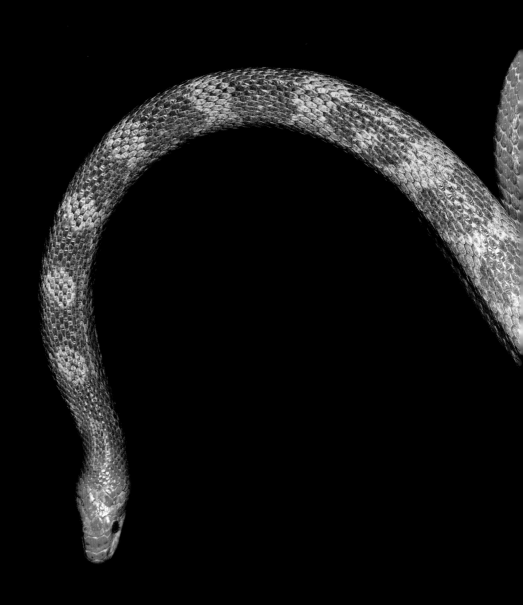

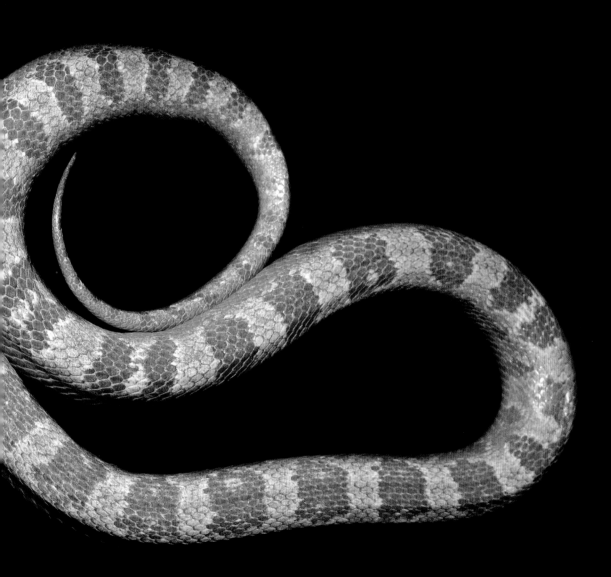

Spiny Mouse

Named for the coarse hairs on its back, which become stiff and spiny when stroked the wrong way, the spiny mouse thrives in very hot temperatures. These highly social rodents live in small family groups centered around a dominant male, but all family members help in caring for young mice. Most remarkably, the spiny mouse is the only mammal known to be capable of tissue regeneration. This little mouse can escape predators by losing patches of skin; it is then able to completely regrow that same skin, as well as fur, sweat glands, and even cartilage, without scarring, much as a lizard regrows a tail.

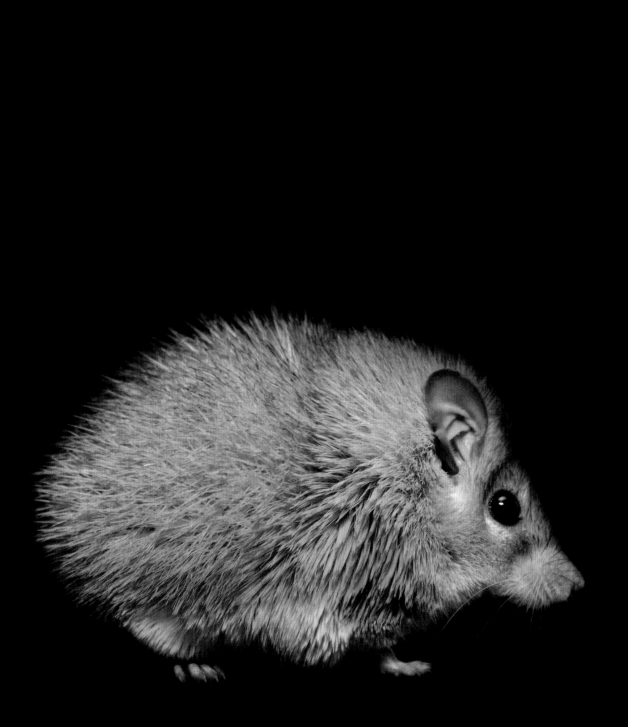

Small-Eared Galago

Galagos, more commonly known as bush babies, are tiny African primates with remarkable jumping abilities. Thanks to elastic energy stored in the tendons of their lower legs, small-eared galagos can jump six feet straight up in the air. Long, humanlike fingers with disks of thick skin at the tips also help galagos to hold on to tree limbs as they climb and jump from branch to branch. Galagos are seen almost exclusively at night; the word for this nocturnal animal in the Afrikaans language is *nagapie*, meaning "little night monkey."

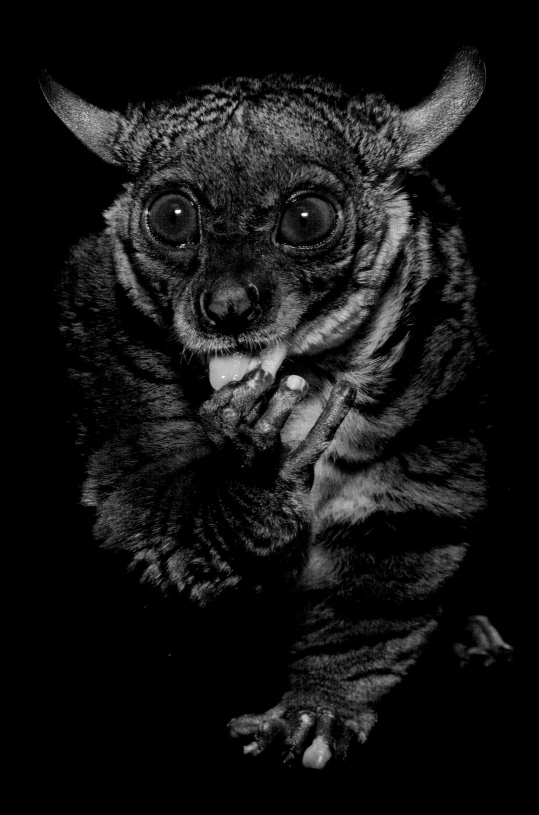

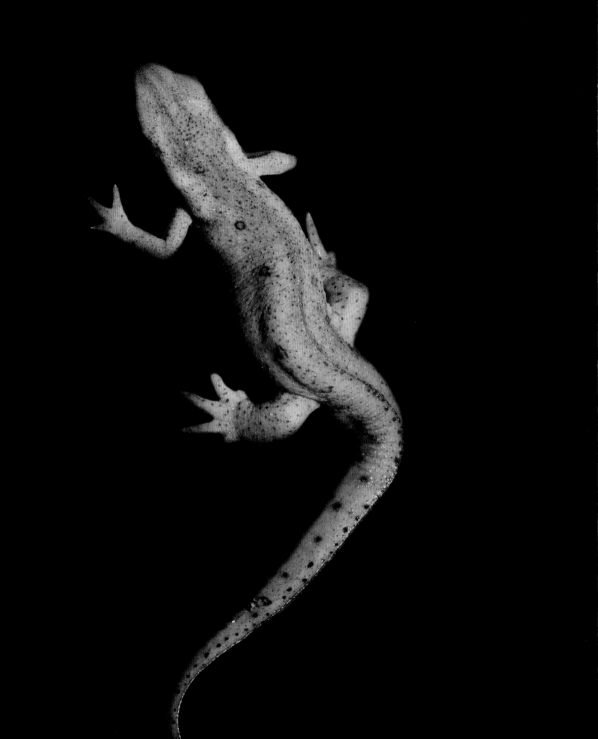

Red-Spotted Newt

These aquatic amphibians live in ponds, lakes, marshes, and streams in much of North America. The red-spotted newt can live for up to fifteen years and has three primary life stages, during which it switches back and forth between living in water and on land. As larvae and then later as adults, the newts use gills to breathe underwater, but juvenile newts (called efts) develop lungs and become terrestrial for up to seven years. Efts are nocturnal while living on land.

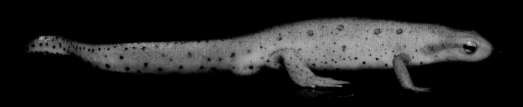

North American Porcupine

Contrary to popular belief, the North American porcupine cannot shoot its quills, which are actually attached hairs with barbed tips that act like fishhooks. When the porcupine is threatened, this prickly mammal will raise its quills, turn its back on its opponent, and then try to hit the target with its tail. If contact is made, the quills instantly become embedded. Slow-moving and nearsighted, the porcupine is not generally aggressive and uses its quills solely as a defense mechanism. The term *porcupine* derives from an old French word meaning "spiny pig," despite the fact that these nocturnal, foraging herbivores are rodents and not related to pigs.

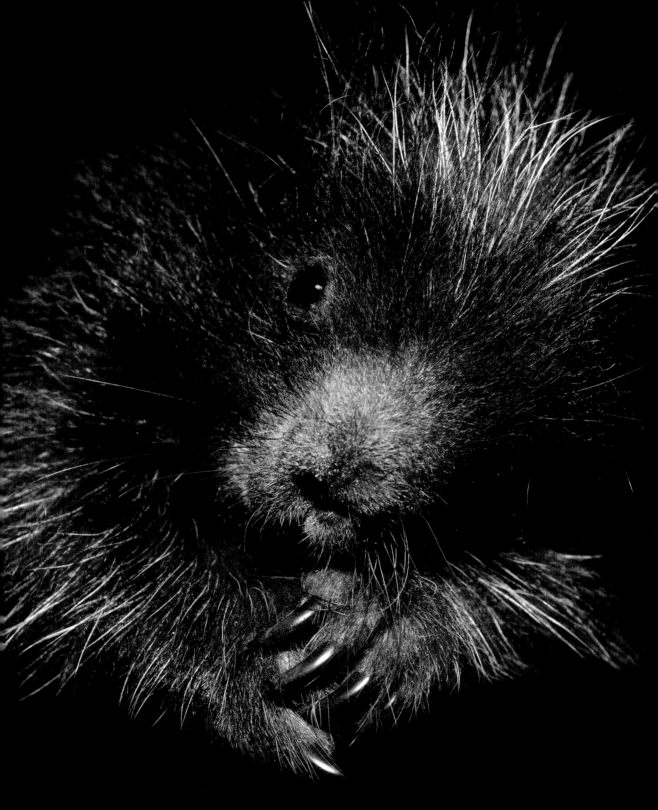

Tarantula

There are more than eight hundred species of tarantula, found across more than half the planet and including the largest spiders in the world. These hairy arachnids have retractable claws on their legs (much like those of cats), which help them to maintain a good grip on surfaces while climbing. (Even a minor fall could crack the spider's fragile exoskeleton and be fatal to a tarantula.) Unlike many other spiders, tarantulas do not spin webs, but they do produce silk. Female tarantulas often use their silk to decorate and strengthen the interior walls of their burrows. They also make silken cocoons for their eggs. The tarantula hunts solely at night, using stealth and speed to sneak up on its prey.

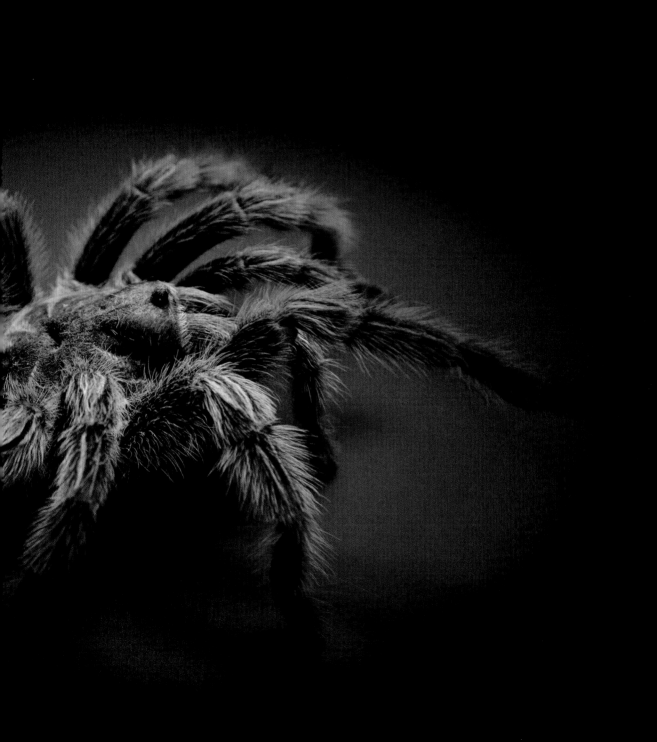

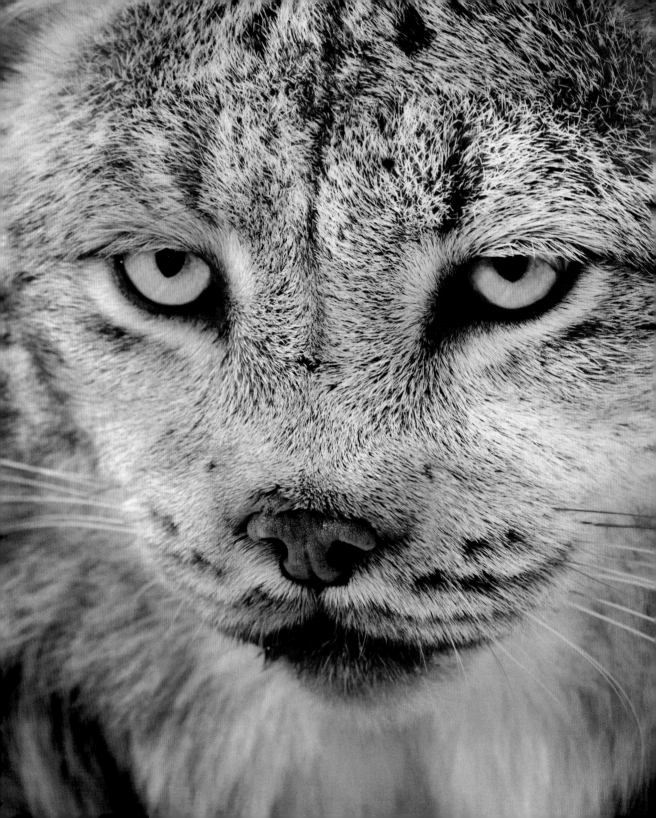

Canada Lynx

Often referred to as the "gray ghost," the elusive Canada lynx is primarily found in the most northern parts of Canada and the United States. This feline predator survives almost exclusively on snowshoe hare, so much so that the two populations fluctuate in sync. The lynx has wide, round, heavily padded paws, which help the feline evenly distribute its weight over the snow, and a dense coat to keep it warm in the coldest of climates. In most regions Canada lynx populations are considered stable, and the lynx is legally trapped and hunted for the fur trade. The Canada lynx is a solitary nocturnal hunter whose large eyes can spot prey up to 250 feet away in complete darkness.

Beaver

"Busy" beavers are the architects of nature, capable of building incredibly complex dams, canals, and lodges, thereby significantly altering their environments to suit themselves. The beaver is the second-largest rodent (behind the capybara) and is semiaquatic, meaning that it primarily lives on land but spends a great deal of time in the water. Beavers are excellent swimmers and have an additional set of eyelids, which are transparent and help them to see underwater. They are very social and live in family groups composed of monogamous parents, newborns, yearlings, and, in many cases, extended family. The nocturnal beaver usually emerges from its lodge at dusk and does most of its foraging and building under the cover of darkness.

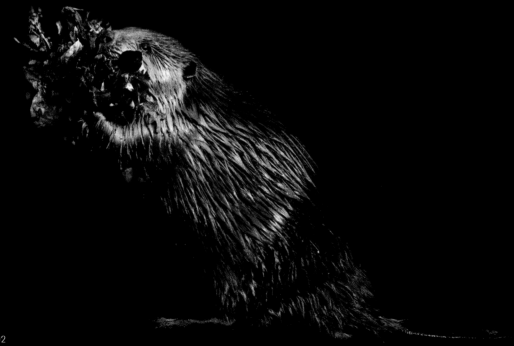

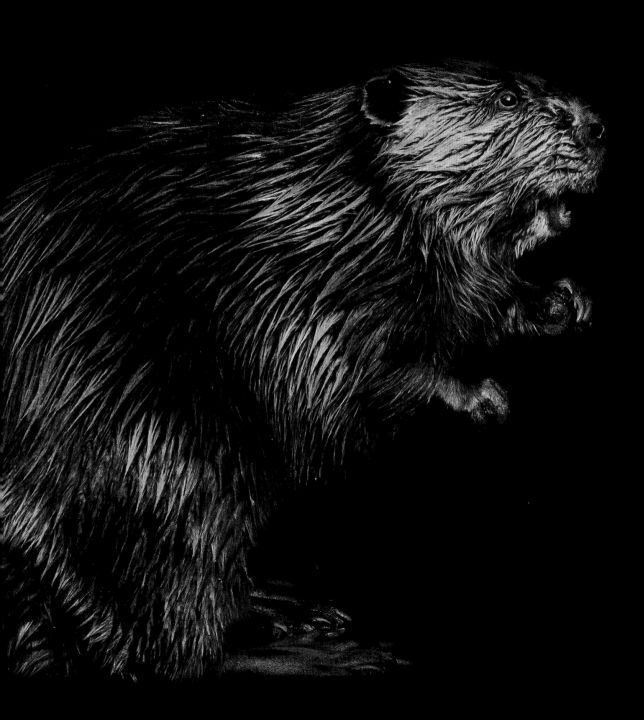

Sugar Glider

This tiny marsupial is actually a gliding opossum with opposable fingers and toes. Although omnivorous, sugar gliders are known for being particularly fond of sweet foods such as nectar and fruit. Often referred to as a "pocket pet" because of its miniature size and enjoyment of hanging out in pouches, the sugar glider is a popular exotic pet. Sugar gliders can form very strong bonds with their human families, but as highly social animals they should live in pairs or small groups and must have a spacious enclosure, as well as a carefully monitored diet. These strictly nocturnal creatures will sleep curled up in a pouch during the day and romp around at night, sometimes barking or chirping when excited or frightened.

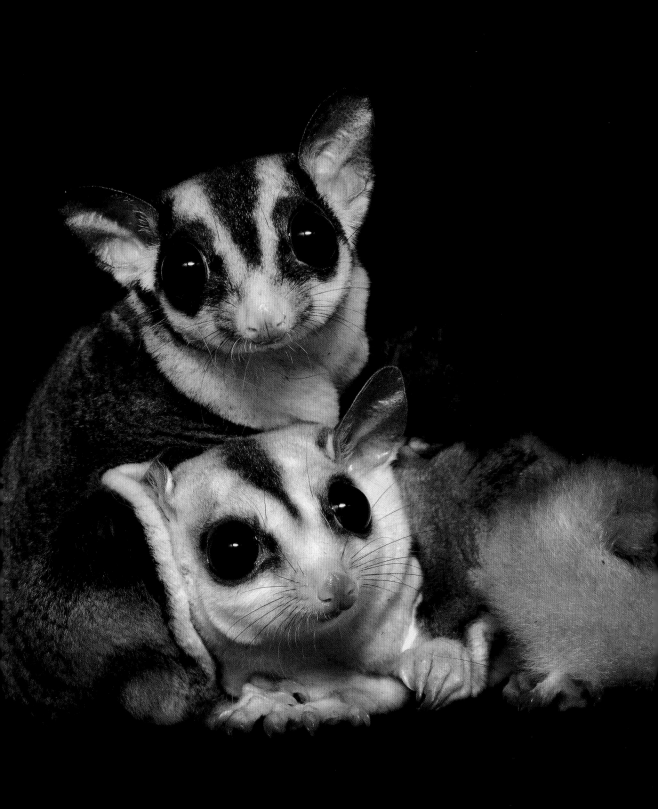

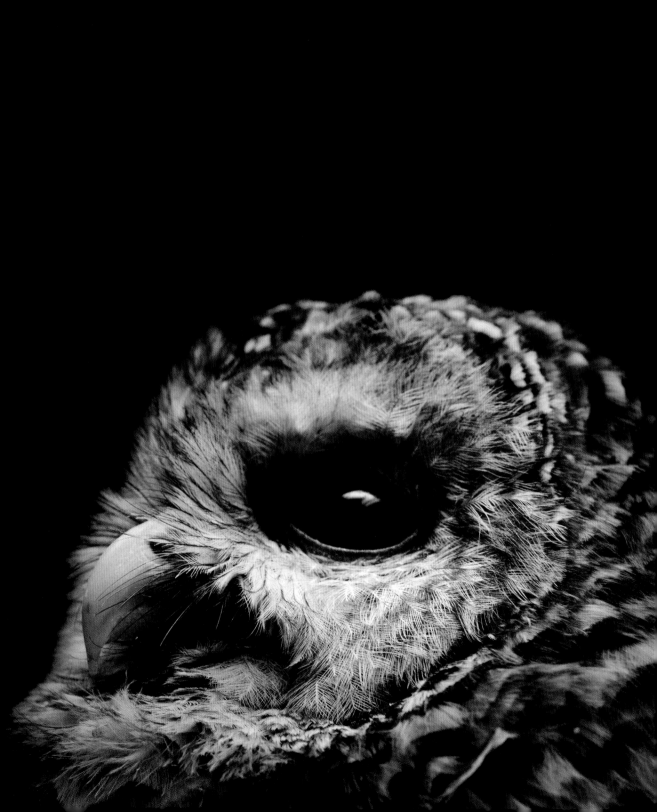

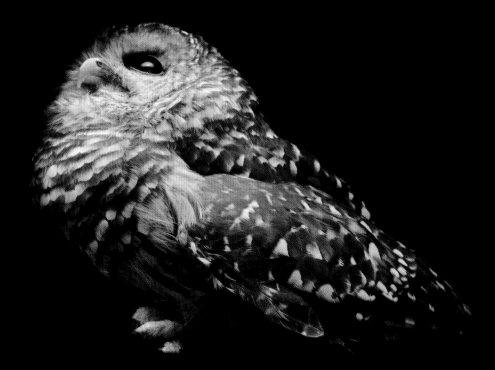

Barred Owl

Fossils of the barred owl from up to eleven thousand years ago have been found in the United States and Canada. Barred owls do not migrate; they live year-round in mature forests with a mix of deciduous and evergreen trees. These noisy raptors are very vocal, and during courtship they will often communicate through myriad sounds, including hoots, gurgles, cackles, and caws. Like most owls, barred owls are nocturnal hunters, but their trademark eight-to-nine-note call can sometimes be heard during the day. The hooting call of the barred owl is said to sound like the phrase "Who cooks for you? Who cooks for you all?"

Red Panda

Although the cuddly looking red panda appears similar to a raccoon, it is neither a panda nor a raccoon. It is, in fact, the only living species of its own genus and family, making it a "living fossil." Native to the Himalayan Mountains and parts of China, the wild red panda population has been declining rapidly in recent decades and is considered vulnerable, primarily because of poaching and habitat loss. Red pandas adapt well to life in captivity and are found in zoos around the world but are not domesticated animals. These heat-intolerant creatures generally sleep in trees during the day and forage for food at night in cooler temperatures.

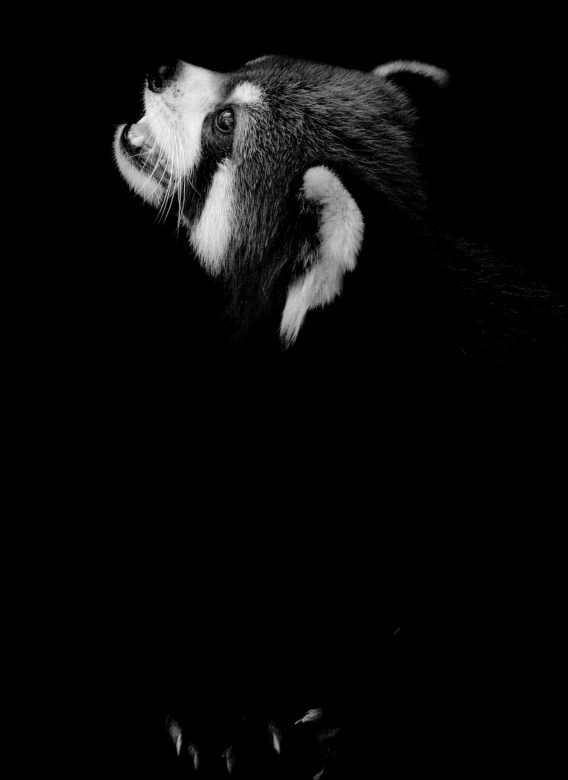

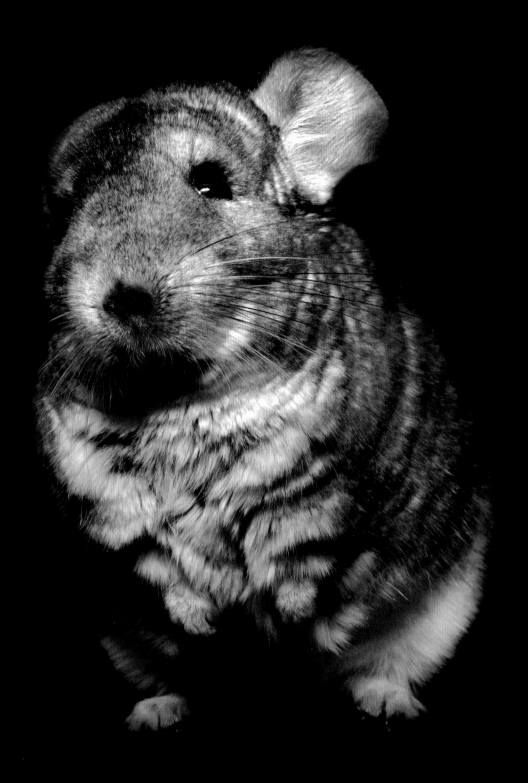

Chinchilla

Humans have hunted the gentle chinchilla for centuries for its soft, velvety fur. Although most chinchillas used by the fur industry are now farm raised, the squirrel-sized rodents have nonetheless experienced a 90 percent global population loss over the past fifteen years. Because of poaching and destruction of habitat, they are now critically endangered, and it is estimated that chinchillas may become completely extinct in the wild within ten years or less. Farm-bred chinchillas are popular pets but require careful care, including a steady temperature, proper diet, mental stimulation, and lots of exercise, in order to thrive. Though more lively at night than during the day, chinchillas are not strictly nocturnal, but rather crepuscular (most active at dawn and dusk).

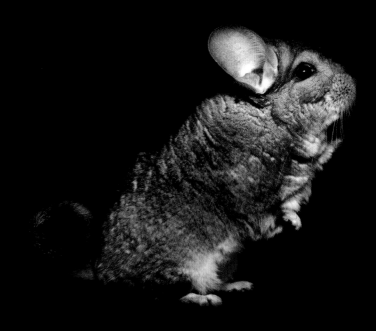

North American River Otter

The playful North American river otter is equally adept
on land or in the water. These members of the weasel
family have a thick, water-repellent coat that allows them
to catch fish and swim even during winter months.
River otters need thriving natural ecosystems with clean,
accessible water in order to survive. Unfortunately,
populations have been declining for decades as a result
of environmental pollution and habitat loss. River otters
are primarily nocturnal in the spring, summer, and fall
but adopt a more diurnal lifestyle in the winter months.

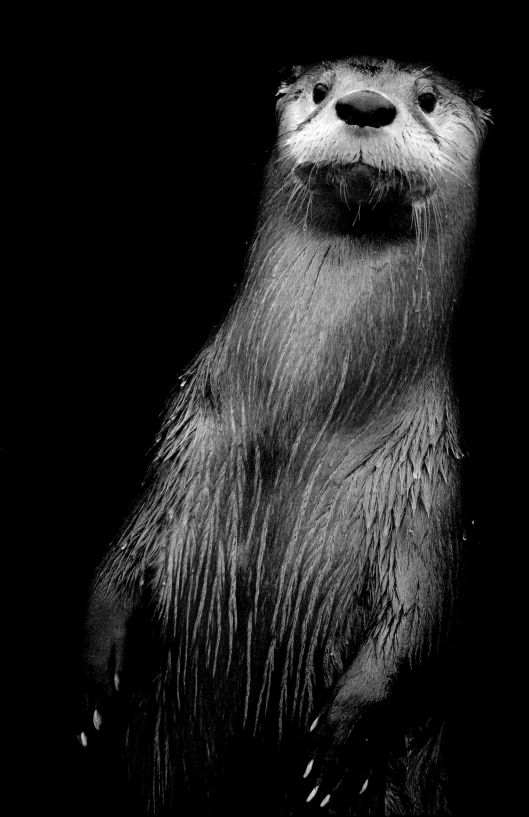

Pygmy Slow Loris

This small, tree-dwelling primate is found in the forests of Southeast Asia. The pygmy slow loris population in Vietnam faced near extinction in the 1970s and '80s, after widespread burning, clearing, and the use of chemicals like Agent Orange during the Vietnam War caused extensive habitat loss. Wild populations continue to be threatened by hunting and habitat degradation. The pygmy loris is frequently captured and sold into the exotic pet trade in Vietnam and Cambodia, where it is also hunted for use in traditional Asian medicine. Since the pygmy slow loris is strictly nocturnal, arboreal, and native to areas with a history of political unrest, accurate population data on the species is hard to find.